NEW MALDEN
THROUGH TIME
Tim Everson

AMBERLEY PUBLISHING

For Jill, Emma and Amanda, for all their help

First published 2011

Amberley Publishing
The Hill, Stroud
Gloucestershire, GL5 4EP

www.amberley-books.com

Copyright © Tim Everson, 2011

The right of Tim Everson to be identified as the
Author of this work has been asserted in accordance
with the Copyrights, Designs and Patents Act 1988.

ISBN 978 1 4456 0537 1

British Library Cataloguing in Publication Data.
A catalogue record for this book is available from
the British Library.

Typeset in 9.5pt on 12pt Celeste.
Typesetting by Amberley Publishing.
Printed in the UK.

Introduction

New Malden begins in 1846. In 1838, the London & South Western Railway built a line to Portsmouth that travelled almost exactly halfway between Coombe Hill – then almost uninhabited – and the village of Malden, now Old Malden to the south. The few locals petitioned for a station, which was duly built in 1846, and it was expected that farmers would walk or ride in a carriage to the station if they wanted a trip up to London. What happened was that building speculators immediately began to build houses in the vicinity of the station, notably The Groves area, and gradually a new town was born, which later became known as New Malden.

The people of New Malden originally paid rates to Kingston, but were dissatisfied with the services, or lack of them, which they received in return, and in 1866 local worthies set up New Malden Local Board. This energetic body soon organised proper drainage, built a church and a school and encouraged the development of shops in Malden Road (now the High Street). This, along with the opening of a branch line to Kingston in 1865, attracted more people to settle in the area and the town's future was assured.

In 1895 the Local Board was redesignated an Urban District Council and took control of affairs in Coombe and Old Malden as well. These two districts are also covered in this book. Coombe, rather like Wimbledon Hill to the east, became a favoured country retreat of wealthy Victorians. John Galsworthy's father built three large houses here – so large that the two surviving houses are now both schools – and the *Forsyte Saga's* Robin Hill was based on the area. Malden was a small village mentioned in Domesday and has been known as Old Malden in contrast to the New since the 1870s. It is a pretty rural survivor squeezed between the built-up areas of New Malden and Worcester Park.

The Kingston bypass, the first bypass in the country, was opened in 1927 to the east of Coombe and New Malden, and north of Old

Malden. Now part of the A3 this, along with the general housing boom of the 1920s and 1930s, filled in all the remaining farmland in the Urban District with new housing. In 1936, New Malden became a Borough – one of the few Boroughs created under King Edward VIII – and the population boomed. Unfortunately, there was a further local government reorganisation in 1965 and, against the wishes of the locals, New Malden (along with Surbiton) was joined to Kingston to create the new Royal Borough of Kingston upon Thames – a London Borough rather than part of Surrey. Local Government now moved out of the town and into Kingston, and New Malden sometimes feels the same neglect that the original inhabitants had felt in the 1860s. Nevertheless, New Malden does manage to keep a sense of community. It still has its flagship department store – Tudor Williams – two supermarkets and its own local magazine, *Village Voice*. While there may be rather more charity shops than is perhaps beneficial to the town, the recent influx of Koreans, who now form more than a quarter of the local population, has really helped to stimulate the local economy.

The photographs in this book cover all aspects of New Malden's past. Whilst many of the old pictures are Victorian, I have tried to include a lot from more recent times, which show similar dramatic changes and have an advantage of being in the living memory of many readers. The main change is, of course, the traffic. Some modern pictures are impossible to manage without cars and to not have cars in the pictures would be a lie about what New Malden is like today. An empty High Street is an impossibility, and many of the private roads have endless cars parked in the street because the houses were built without drives or garages.

On the plus side, New Malden is a much greener place than it was 50 or 100 years ago. As with my Kingston book, it was not something I really noticed until I tried to take some modern pictures. The High Street, for example, has many more trees than before and trees are of course larger and bushier than when they were first planted. I hope you enjoy this selection as much as I have enjoyed producing it.

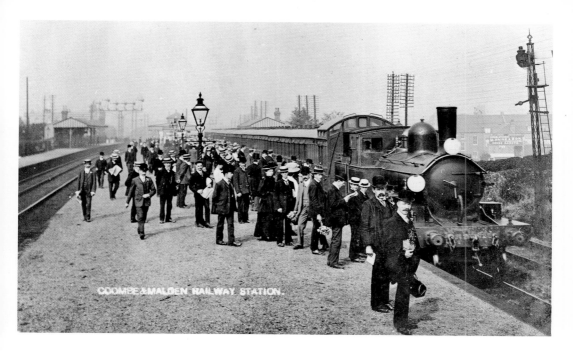

COOMBE & MALDEN RAILWAY STATION.

Where It All Began

New Malden station was a small hut-like structure up a steep flight of steps when it opened in 1846 to serve the residents of Coombe. It was originally called Malden for Coombe. By the time of the above photograph of *c.* 1910, it was Malden and Coombe. It was not named as New Malden station until after the Second World War. The two central platforms, 2 and 3, are no longer used.

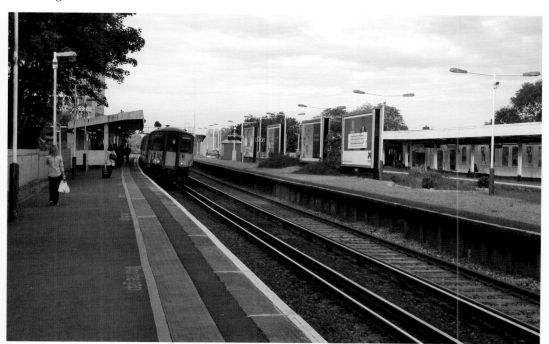

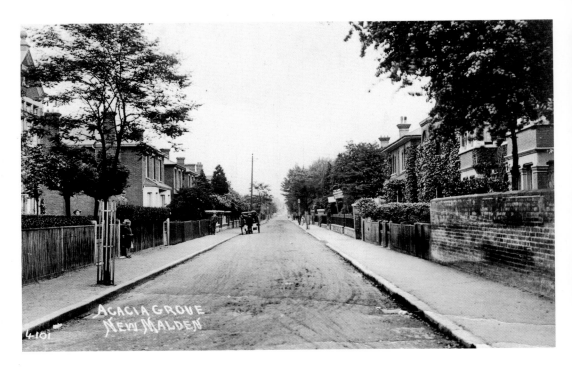

Acacia Grove

The Groves were laid out north of the station as a building speculation in the 1850s. This postcard of around 1900 shows Acacia Grove. The note on the back of it reads, 'This shows a little piece of our house. My little son is at the gate. This is a view of the end of the Grove looking up.' This last statement was unhelpful in locating the house, but it still stands. The view is looking east.

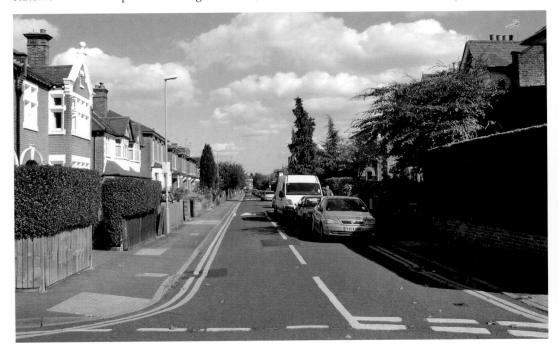

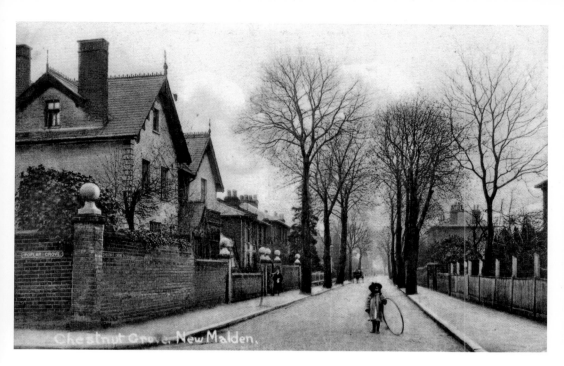

One Ball Left

This is Chestnut Grove, also looking east from Poplar Grove on a postcard dated to 1909. The two big houses on the left and much of the boundary wall have disappeared, but a solitary stone ball remains in the middle distance. The Groves are somewhat blighted today by cars, and many of the larger trees have gone.

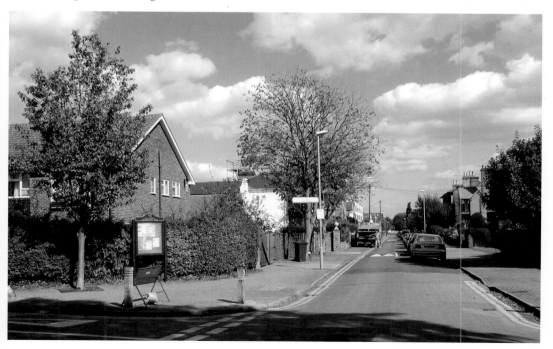

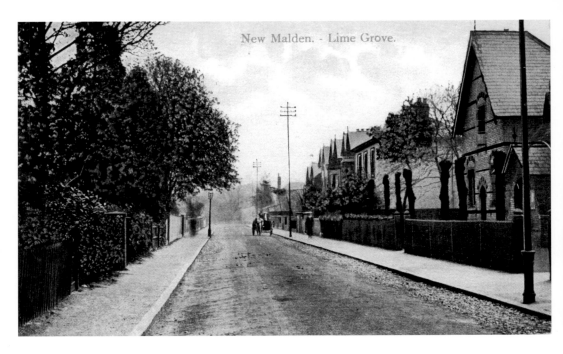

Christ Church School

The row of rather stunted lime trees on the right of this 1906 postcard are in full leaf today, and combine with the telegraph pole in obscuring the porch of Christ Church Junior School in Lime Grove. The building to the left of the porch has been pulled down, while the buildings to the right in the modern picture were out of shot on the old postcard.

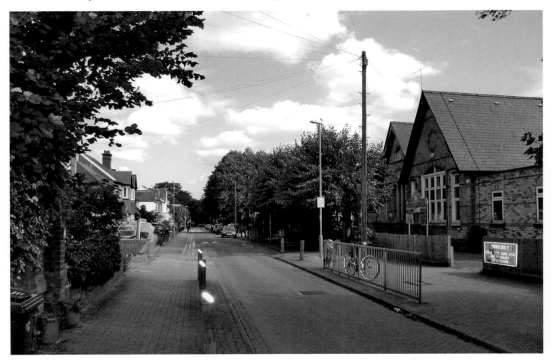

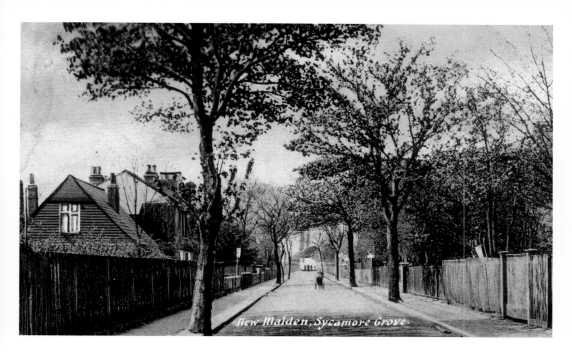

Sycamore Grove

Unlike the other Groves, which today are in a Conservation Area, Sycamore Grove had few houses, especially on the north side when this postcard was taken in 1910. It was mainly a home to minor industries. Today, the houses on the north side are from the 1920s and 1930s, whilst there are also several more recent apartment blocks like Edgar Court, shown here on the left.

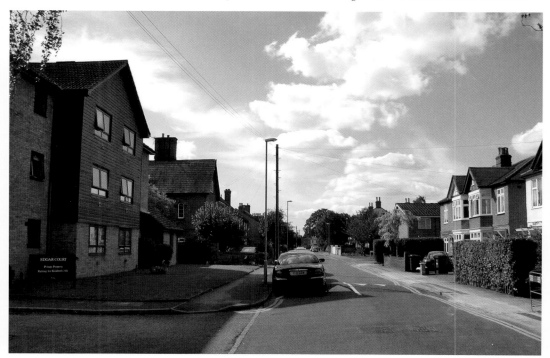

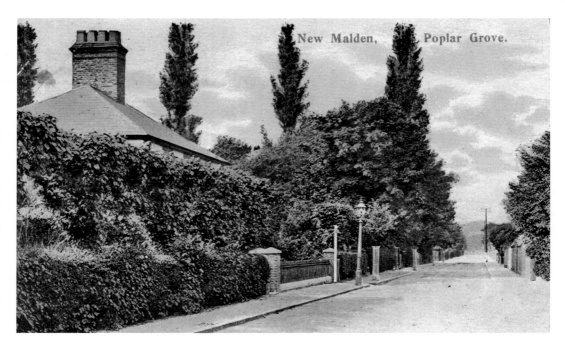

Poplar Grove

Poplar Grove was named for the poplar trees in this postcard of 1906, but they have long gone. This card was sent from a lady called Hilda to Miss Benson in Wimbledon explaining that she was unable to come that afternoon as she was having a party. Postcards were frequently posted in the morning with the secure knowledge that they would arrive by lunchtime.

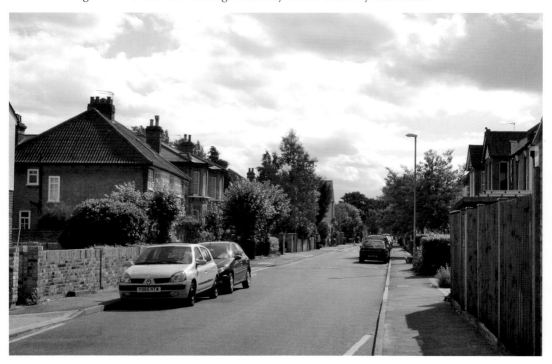

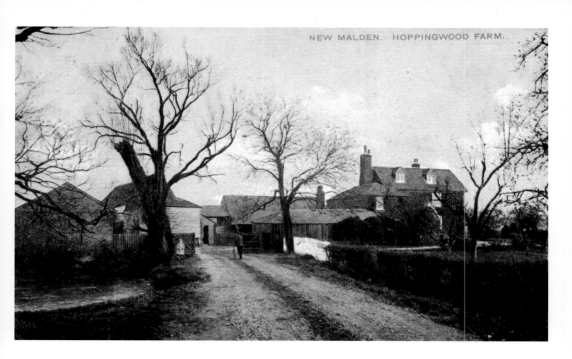

NEW MALDEN. HOPPINGWOOD FARM.

Now That Has Changed

Hoppingwood Farm owned nearly all the land east of the present Coombe Road and High Street in the nineteenth century, with the railway splitting its land in two. The owners gradually sold off fields for building development and the farm itself was demolished during or shortly after the First World War. The site is now covered by the houses and gardens on the west side of Rosebery Avenue.

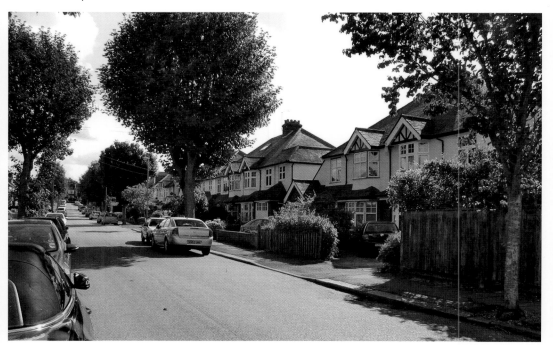

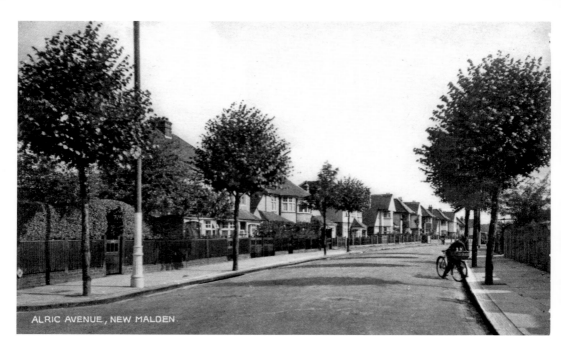

ALRIC AVENUE, NEW MALDEN.

Alric Avenue

Alric Avenue was laid out in 1900 and some houses were built on the south side, but the First World War interrupted, and the houses visible in this picture date from the 1920s. As can be seen, there has been very little change since then, except for the cars.

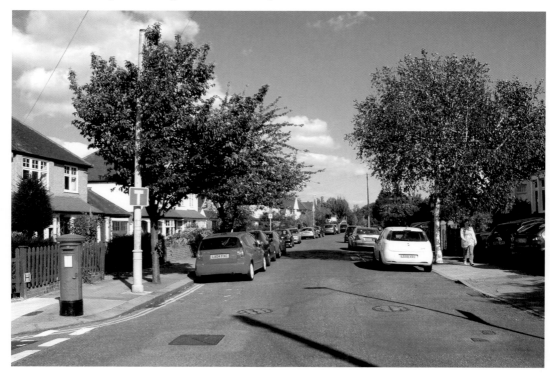

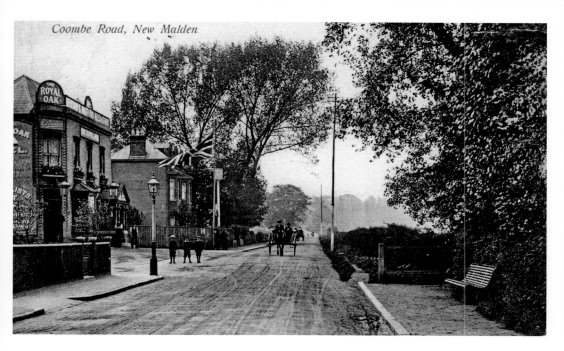

Coombe Road, New Malden

School's Out

Robert Dickason was landlord of the Royal Oak when this postcard was taken in 1905, and may have been responsible for the complete rebuild that took place at about that time. Always busy, this stretch of Coombe Road has a pavement full of Coombe girls at the end of the school day.

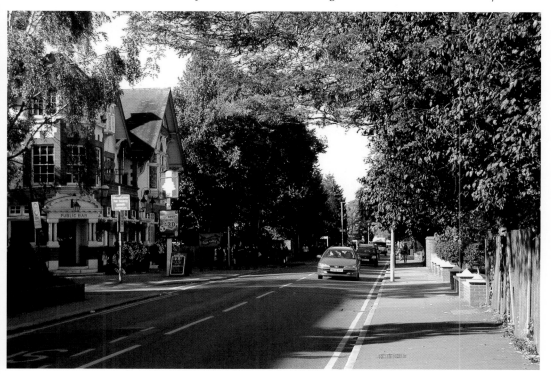

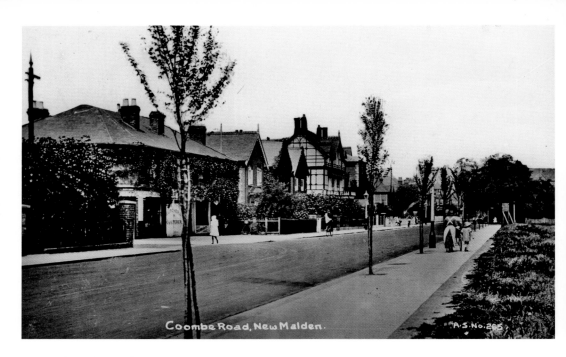

Coombe Road, New Malden.

A.S. No. 265

Butcher's and Baker's

The white gates on this Edwardian postcard of Coombe Road say 'Butchers and Poulterers'. This was John Ratcliff, established in 1894, whose butcher's shop at 54 Coombe Road lasted under his son until 1966. Next door was Charles Smith the baker. The site was redeveloped as Concorde House apartments.

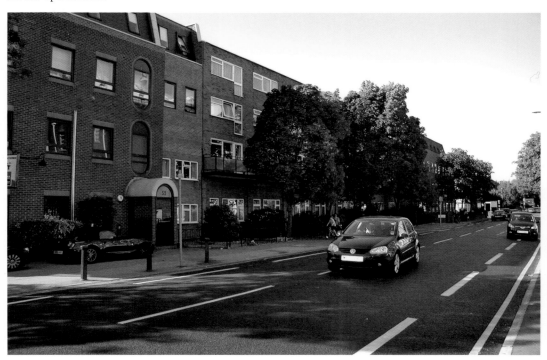

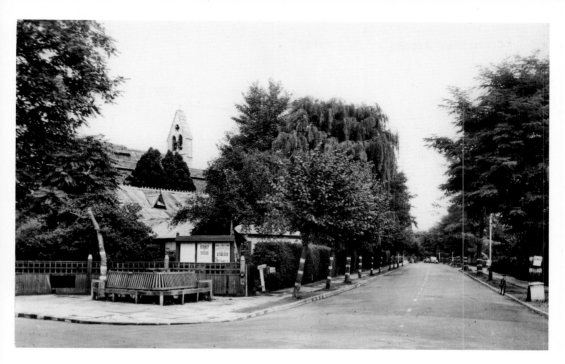

Cambridge Avenue

Cambridge Avenue is named after the Duke of Cambridge, who was the biggest landholder in the area in Victorian times. He was the owner of Hoppingwood Farm, which was leased from him. In 1865 he gave the land for the building of Christ Church on the left of the picture.

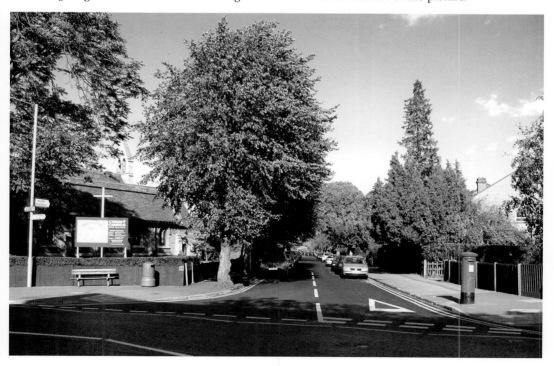

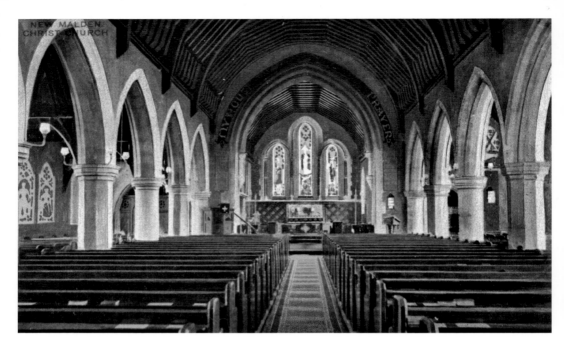

Christ Church

There had been a small temporary church called St James' in Poplar Grove since 1857, but a new 'proper' church was soon deemed necessary. Christ Church was built in 1866 and the new parish of New Malden & Coombe was created out of a part of the parish of St Peter's, Norbiton.

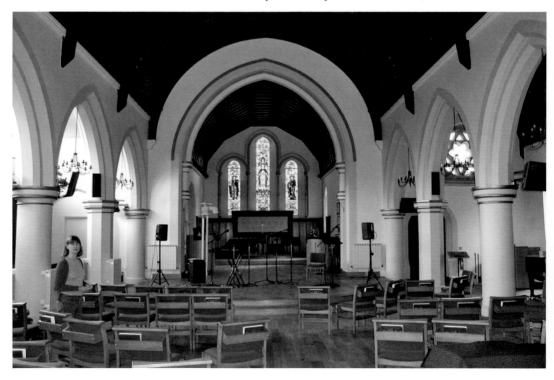

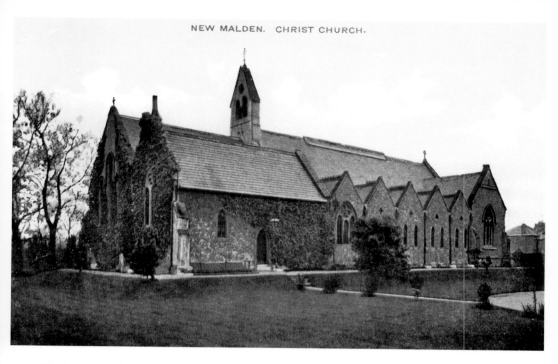

'No More Need of a Church Than There is of a Town'

These were the words used by the MP for West Surrey when petitioned for help in building a church, but the town grew and so did and does the church. The new Christ Church Centre, which obscures this old view of the church, was built in 1980/81.

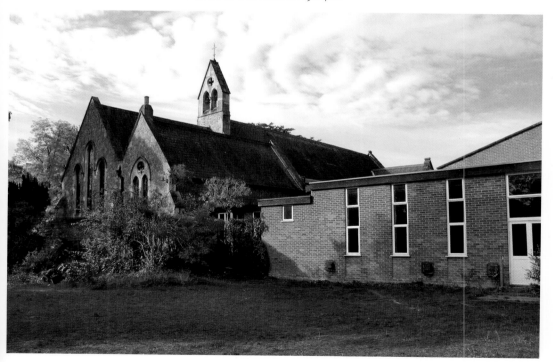

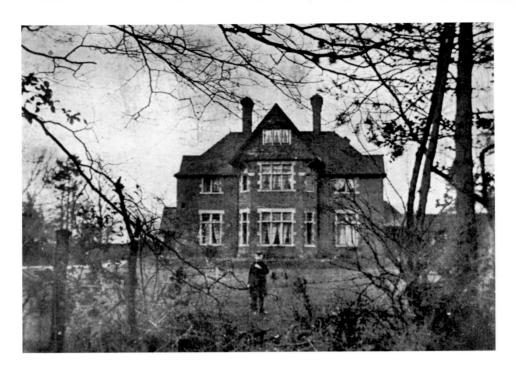

Threatened Treasure

The vicarage of Christ Church was built in 1874 and is now seen as a bit of a liability thanks to the cost of its upkeep. Plans to demolish it and build new apartment blocks on much of the church's land have recently been rejected, but a less ambitious plan might still get the go ahead.

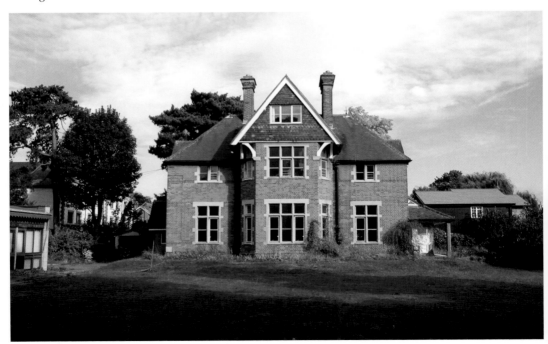

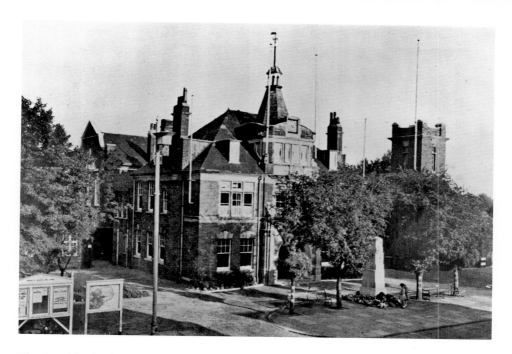

The Municipal Offices

New Malden Local Board was set up in 1866 by residents tired of paying rates to Kingston but receiving few services. In 1895 New Malden joined Coombe and Old Malden to form Malden & Coombe Urban District Council. The splendid council offices and adjoining fire station were built in 1905.

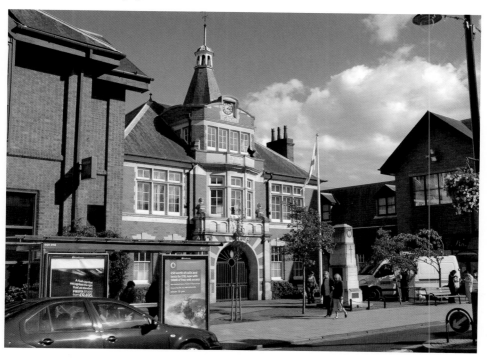

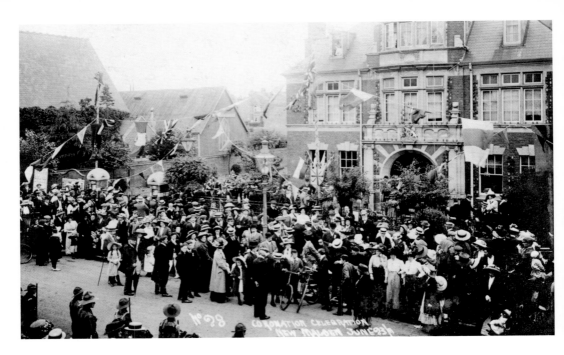

Coronation Celebrations

This earlier photograph of the new municipal offices was taken on 23 June 1911 when George V was crowned. The event was celebrated by unveiling a clock (anonymously donated) on the top of the building. The ceremony was attended by the 1st Malden Scouts, the Church Lads Brigade and the 3rd Battalion of the East Surrey Regiment.

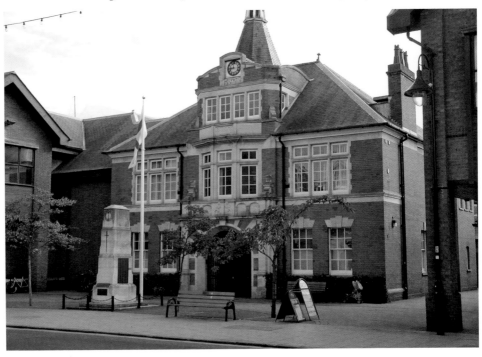

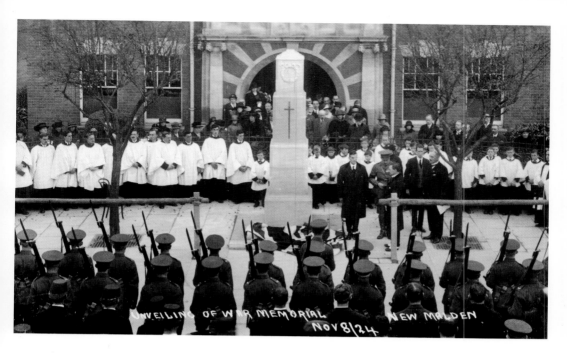

The War Memorial

New Malden's war memorial was unveiled on 8 November 1924 by Private F. Jackson of the Royal Welsh Fusiliers, a local man who had been blinded in the war. Names were added later but they weathered badly, and the memorial was also damaged by bombs in the Second World War. In 1996 the names were replaced with new inscriptions on brass plaques.

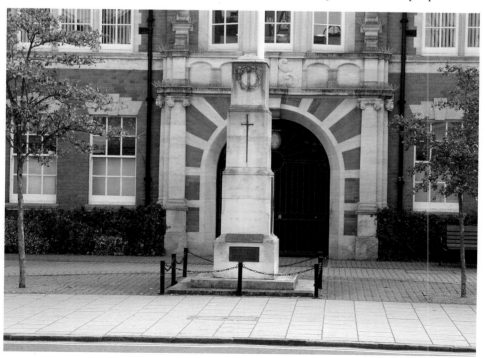

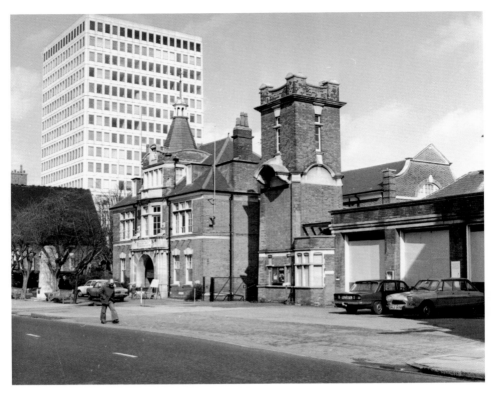

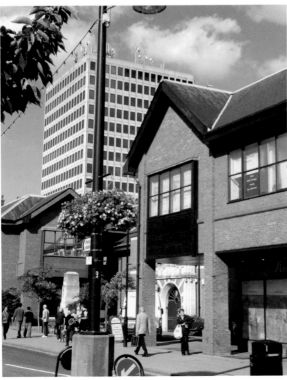

All Change

This view of the municipal offices and fire tower taken in 1979 is now impossible to recreate. Only the front gate and war memorial can be seen. Malden & Coombe became a borough in 1936, but in 1965 it became part of the Royal Borough of Kingston upon Thames, and the municipal offices were no longer needed. The façade survives, incorporated into a Waitrose. The fire tower was demolished.

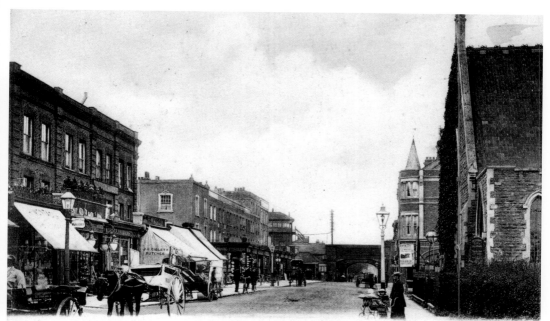

Market Place. New Malden.

The Market Place

Not many people know that this stretch of Malden Road, now the High Street south of the railway, was known as the Market Place before the First World War. The church on the right is the short-lived Holy Trinity (Free Church of England) built by the Revd Stirling, formerly of Christ Church in 1892, because he objected to 'pro-Roman Catholic practices' in the Church of England. On the left is the wonderfully named J. C. Giblett, butcher.

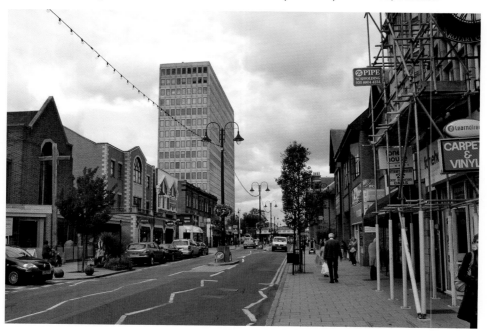

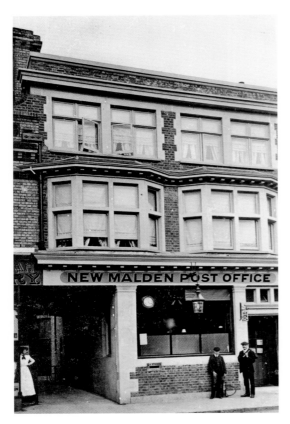

The Original Post Office

New Malden Post Office is pictured here in 1920 at No. 9 Coombe Road, just north of the station. The growing population soon proved too much and it moved to larger premises at the other end of town, 100 Malden Road (now 150–154 High Street). Malden Road from the station to the Fountain roundabout was renamed High Street and renumbered in 1970.

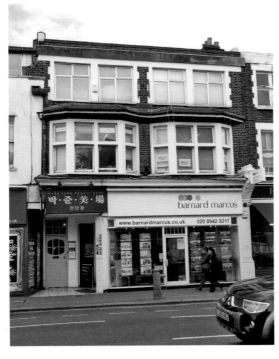

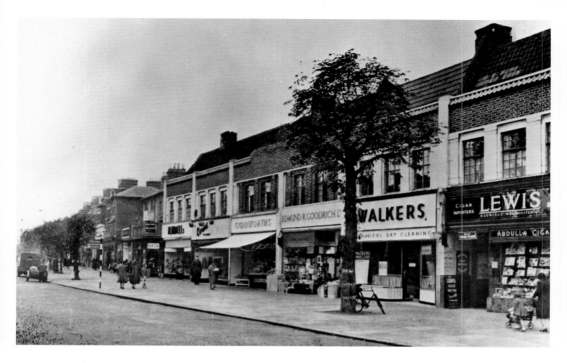

Central Parade

Before the renumbering, Malden Road had more shops than it had numbers because of later building insertions into an old numbering system. Here is Central Parade in 1957, with Nos 1–6 inserted between 99 and 99a Malden Road. The Parade was built opposite Blagdon Road in 1936 replacing the Acme Rustic Works, garden furniture makers.

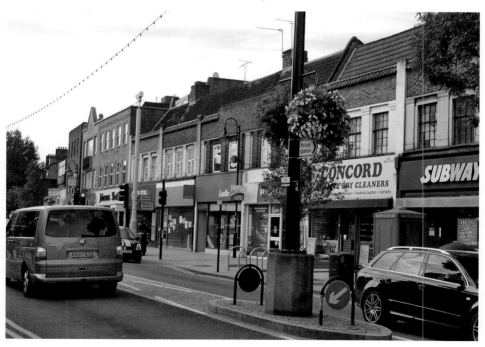

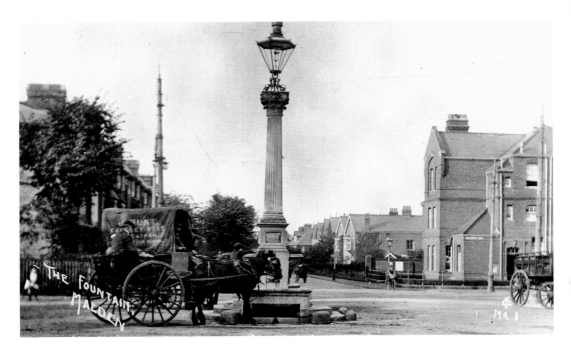

The Fountain

The original Fountain was built in 1894 by the New Malden Band of Mercy as a place for horses, dogs and people to get a drink of fresh water. It was demolished by a cart in 1914, rebuilt, and then demolished by a van in 1932, after which it was replaced by the large roundabout. The modern ornamental fountain on the roundabout was presented by New Malden Rotary in the 1980s.

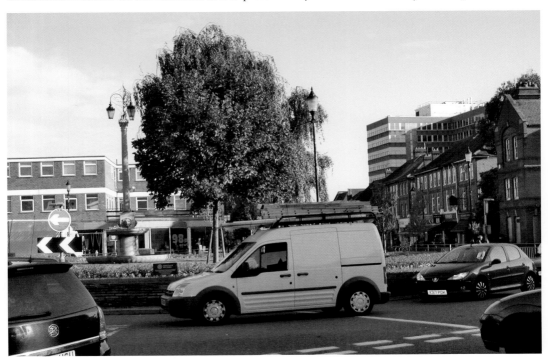

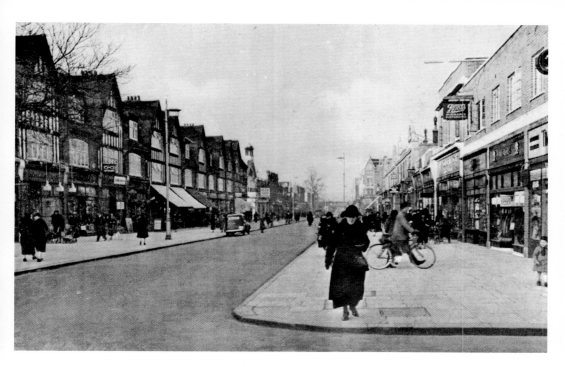

Looking North

This view of Malden Road, now the High Street, is taken from a Malden & Coombe Guide of 1938. Boots on the right is now a WHSmith store. It was then 3 Broadway Parade. The lack of traffic and street furniture is remarkable compared with today.

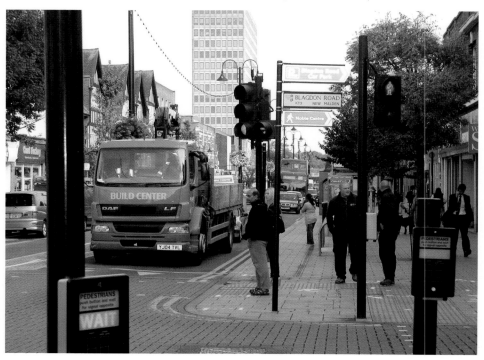

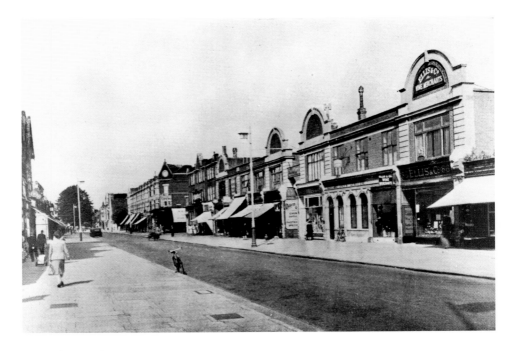

Where's My View?

Street furniture is also most apparent in these contrasting views of today and 1957. Apart from the cars, the view of Lloyds Bank is obstructed by a telephone box, and the skyline is disrupted by the dangling street lights down the middle of the road, not to mention the C. I. Tower. And what happened to the other two architectural semicircles surmounting the buildings opposite?

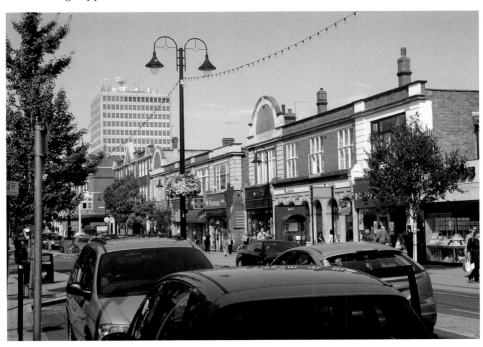

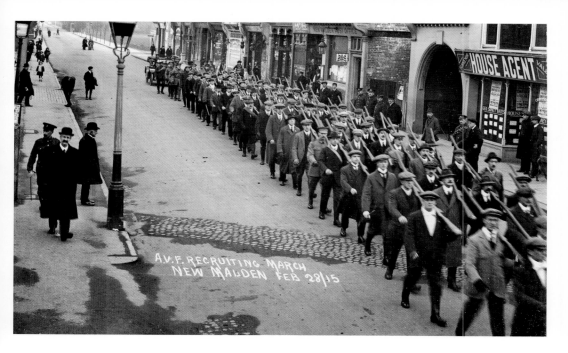

Athletes' Volunteers Force

This is a First World War recruiting march in 1915 in New Malden. The AVF stands for Athletes' Volunteer Force, and they were fit local men wanting to join up. At about this time Kitchener's volunteer army was formed out of these forces. I cannot trace the exact location so for a contrast I give a picture of New Malden Woodcraft Folk marching in Coombe Road during Malden Fortnight.

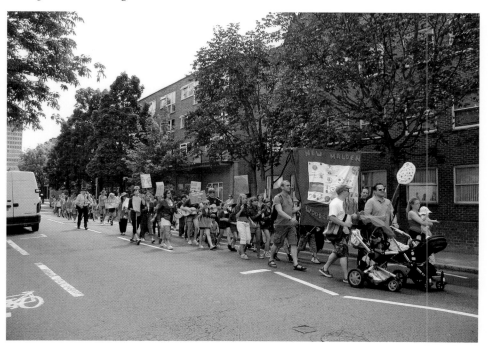

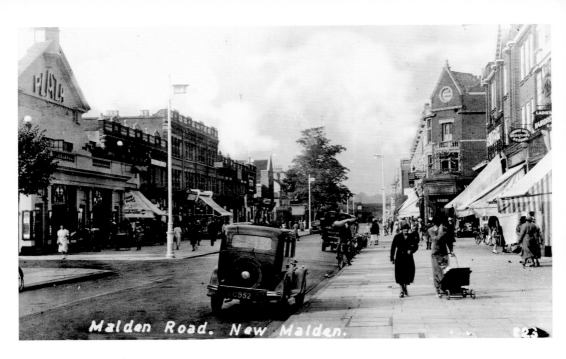

Malden Road – High Street

Malden Road pictured in the early 1930s with the large NatWest bank building on the right, obscured by trees in the modern photograph. The new photograph gives a good view of the lights down the middle of the road, morning rush-hour traffic, and the imposing Apex Tower office block.

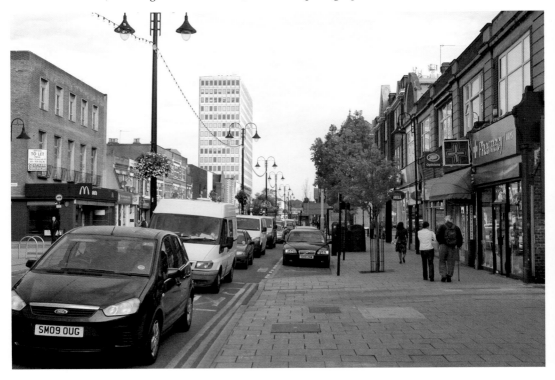

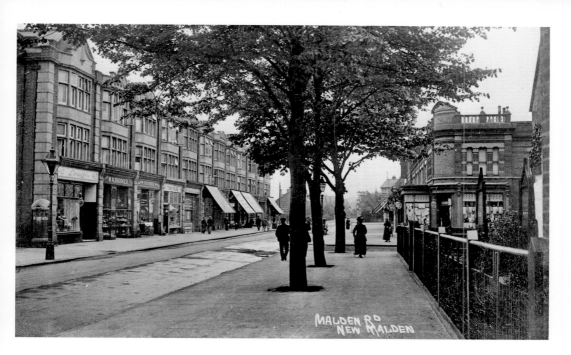

Tudor Williams

Tudor Williams is New Malden's premier department store and it opened at 53–59 Malden Road in 1913, just after this postcard was taken. Tudor Williams would go on to take over the buildings on the right. The modern building is obscured by the large cross and church extension of the 1990s of the United Reformed Church, previously a Wesleyan chapel set further back from the road.

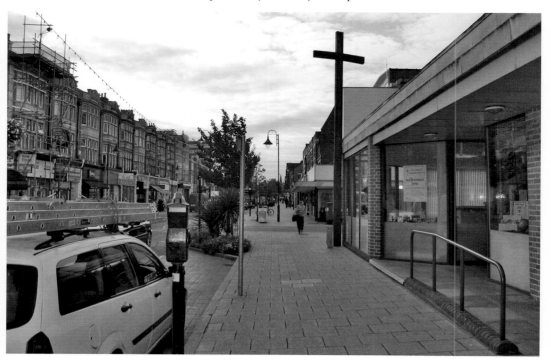

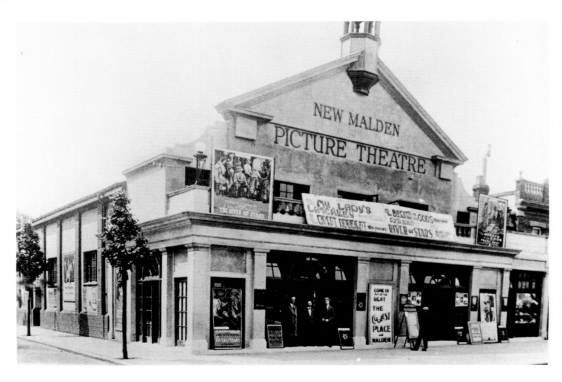

Going to the Pictures I

The New Malden Picture Theatre shown in 1922 had just opened the previous year at the corner of Malden Road and Sussex Road. Renamed 'The Plaza' in 1928, it burned down in 1936, and the site remained empty for twenty years. It then became a Royal Arsenal Co-op, later a painters and decorators, and is now McDonalds.

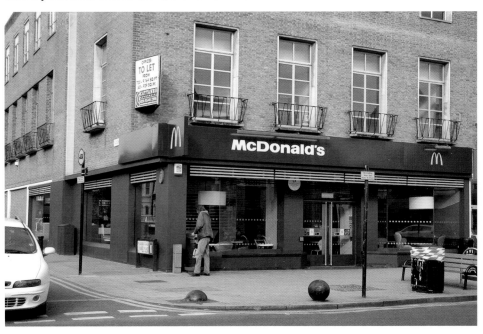

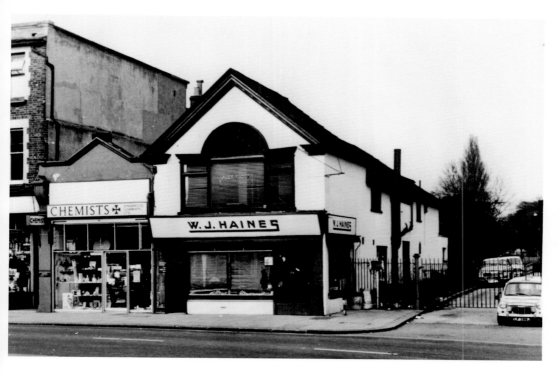

Going to the Pictures II

New Malden used to boast a variety of cinemas. Now there are none. These two buildings housed the first cinema in New Malden, the Cinematograph Theatre – later New Malden Cinema Hall. W. J. Haines, the grocer, dates the top photograph to 1968–73. Today, Sam's Barbers with New Malden Cars above, and the Station Superstore, provide useful services for train travellers.

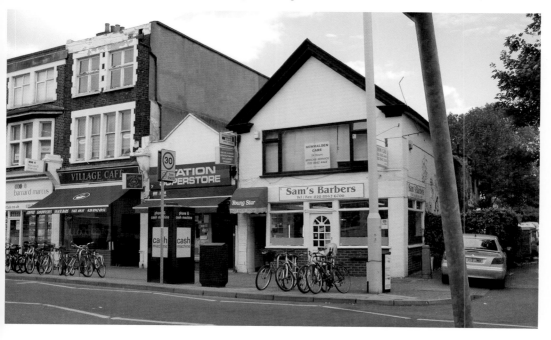

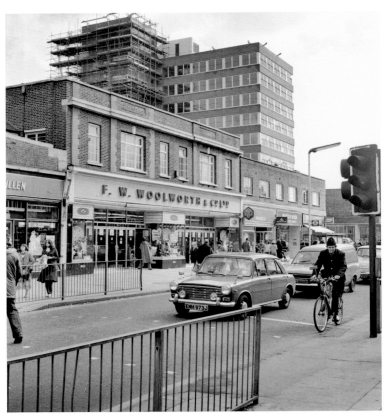

The Wonder That was Woolies

Woolworths was the general store where, originally, everything was priced at 6d (2½p). Inflation means that today's bargain shop charges £1. Woolworths opened in New Malden at 92 Malden Road (now 106–110 High Street) in 1936, following the successful opening of stores in Kingston (1931) and Surbiton (1935). Woolworths went into administration in late 2008, and all its 800+ stores closed.

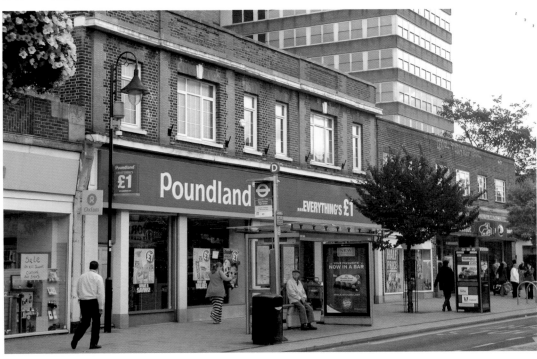

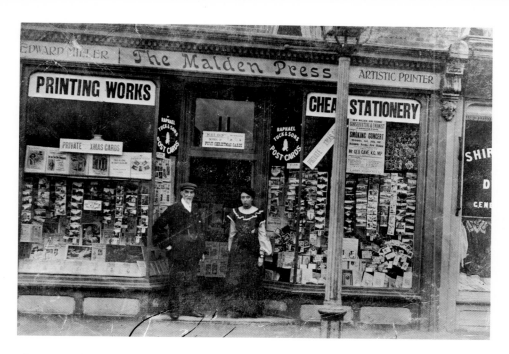

The Malden Press

Many of the early postcards featured in this book will have been sold here at the Malden Press, 11 The Pavement, Malden Road. It moved to these premises in 1906, having previously been known as Miller & Goozee at 7 The Pavement. Before the First World War, the Malden Press moved again to 65 Malden Road where it closed in 1926. Today the 11 The Pavement premises are 73 High Street and half of K-Mart, one of the many Korean shops in the town.

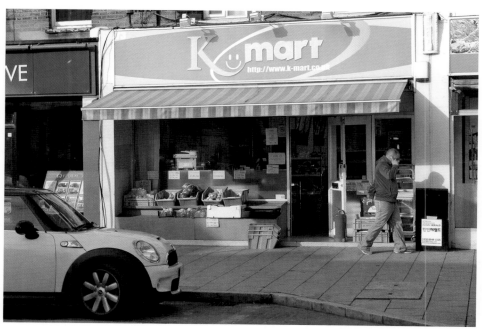

35

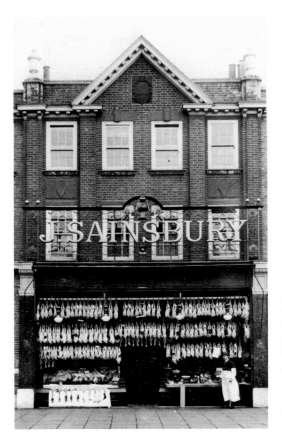

Happy Turkey Day!
Sainsbury's Christmas display of poultry in 1923 would not be allowed today with health and safety rules, but with all the pollution from the traffic, perhaps that's wise. J. Sainsbury opened here in 1921 and doubled the size of the shop in 1963. They pulled out of New Malden in 1990 and were replaced by Blockbuster Video. This has just closed to be replaced in its turn by Peacocks, a clothes shop.

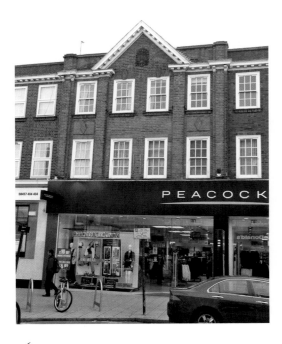

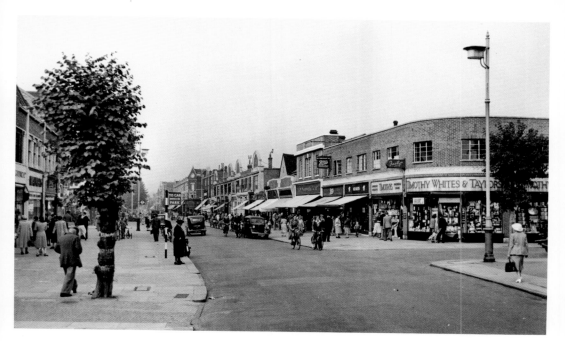

Timothy White's

In 1936, Broadway Parade was built at the corner of Blagdon Road. It consisted of three shops: Boots the chemist at No. 3, Meakers Outfitters at No. 4, and Timothy White's and Taylor's, chemist and hardware dealers at No. 5, later renumbered 5 and 6. There never was a 1 or 2! The shops are now WHSmith, Nationwide and Boots, who moved down when they bought out Timothy White's in 1968.

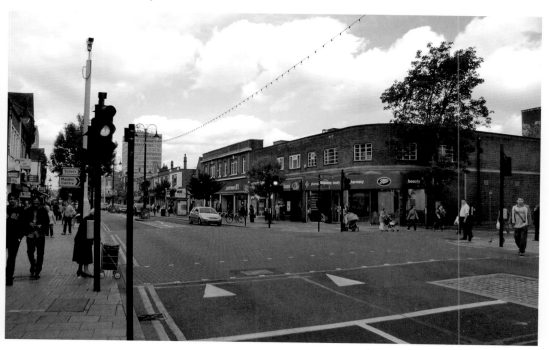

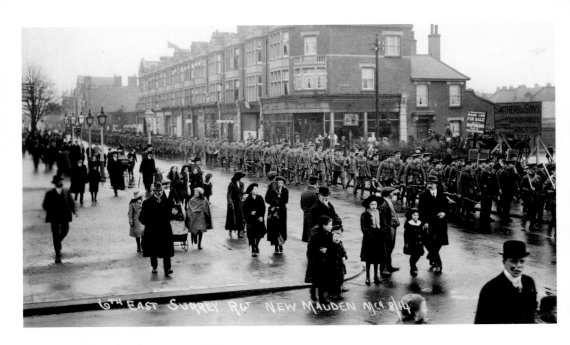

Recruiting for the Expected War

The 6th East Surrey Regiment (Territorials) marching down Malden Road on a wet 8 March 1914. On 7 March they had marched through Richmond, Richmond Park, Kingston and Surbiton. On 8 March they held a service at Christ Church, and then marched through the town and on to the Dittons, the Moleseys and Hampton Court. Forty-five men signed up on those days with more expected to follow.

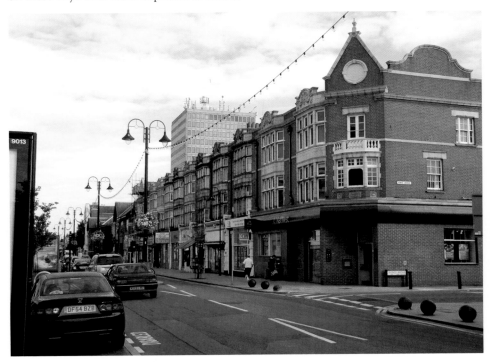

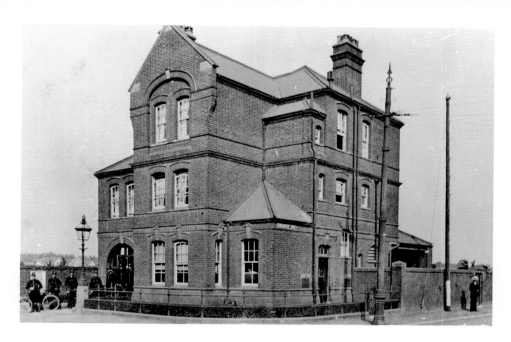

New Malden Police Station

New Malden existed for a generation before it finally got its own police station in 1891, photographed here in 1910. Before then, constables had to come from Wimbledon, Kingston or Epsom and were reluctant to make arrests because of the travelling involved. This majestic building by the Fountain closed temporarily in 1998, reopened in 2001, but closed for good in 2005. It is awaiting redevelopment as a Wetherspoon's pub.

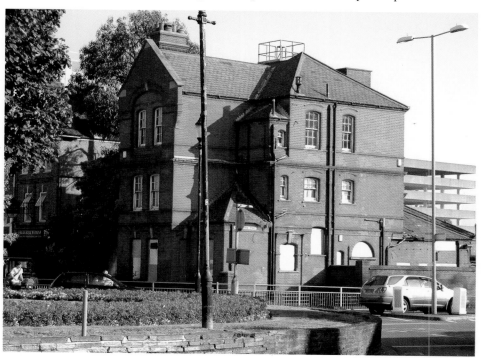

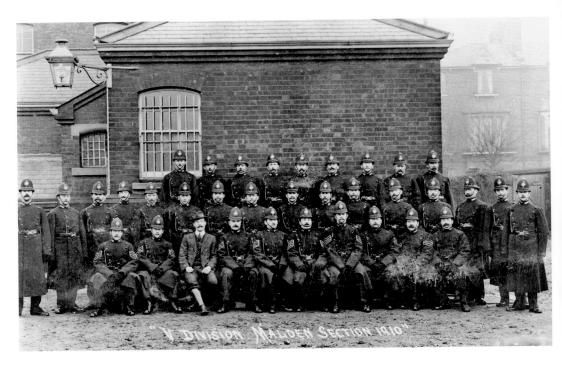

Where Did They All Go?

As the postcard states, this is V Division, Malden Section of the Metropolitan Police photographed in 1910. There were thirty-five policemen here at a time when the population was less than 10,000. Now, with a population of 50,000, New Malden has a police force perhaps a third this size operating from the 'Cop Shop' in the C. I. Tower (closed mornings).

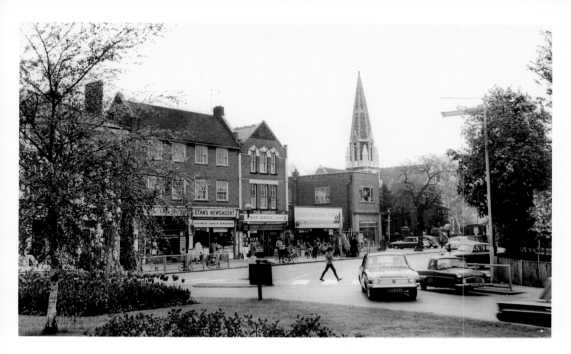

South from the Fountain

Just south of the Fountain roundabout, the Malden Road heads towards the A3. Stan's Newsagent in the 1950s is still a newsagent today, next to another Cop Shop (closed mornings). The sweetshop has become another Korean store, Seoul Plaza, and Malden Building Supplies has been replaced by a new building that obscures the old view of the United Reformed Church.

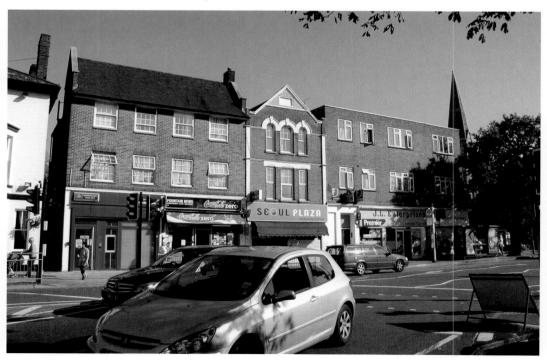

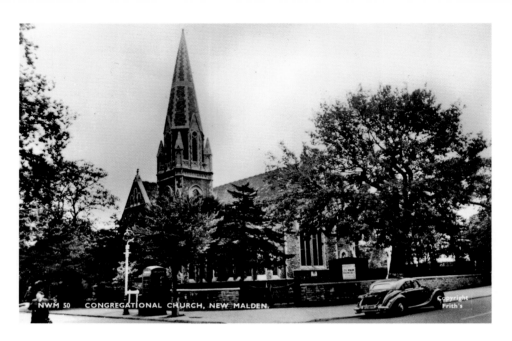

Congregational Church

New Malden United Reformed Church began life in 1881 as a Congregational Church, built on land donated by John King. It was designed by the appropriately named Church & Dove and cost £3,600. When the Congregationalists joined with the Presbyterians in 1972 it became a United Reformed Church. The 1950s view is difficult to match today with trees and traffic getting in the way.

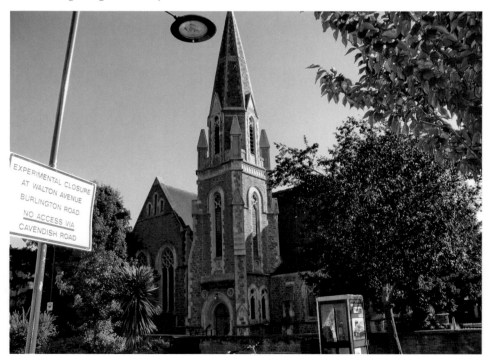

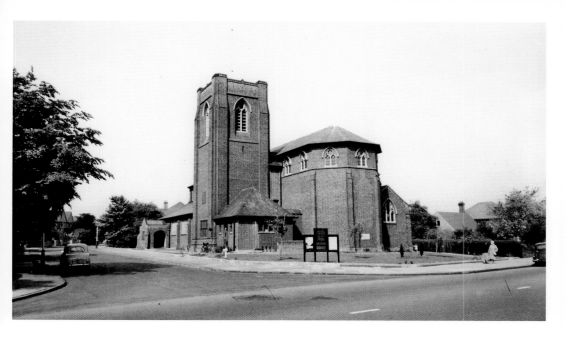

St James' Church

As New Malden continued to expand, especially after the building of Kingston bypass, it needed a new large church to the south. Southwark Diocese set up a building fund from 1925 to 1933 to build twenty-five new churches in the expanding suburbs, and St James' church was one of these, built in 1933 at a cost of £11,600.

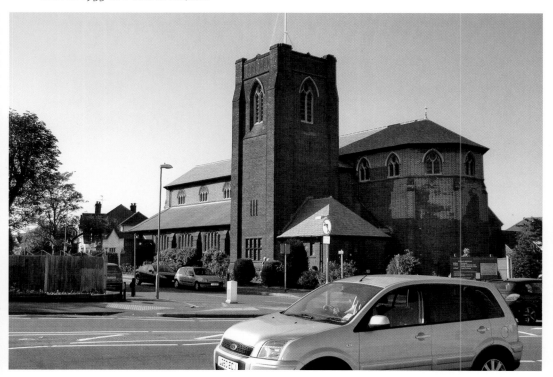

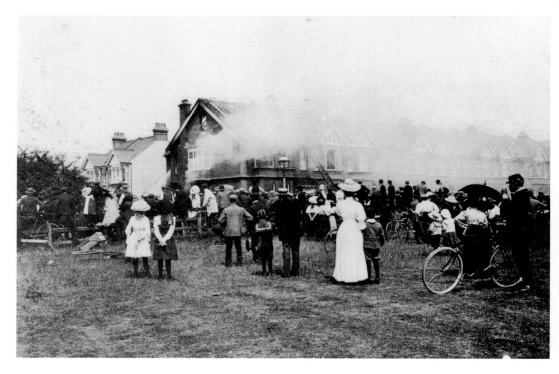

Fire!

Occasionally, postcards can be found of dramatic events, like car crashes and fires. This fire occurred at 1 Blagdon Road at the corner of Howard Road in July 1906. A drum of paraffin used for filling lamps was knocked over and exploded. The sole occupant, Mrs Ellen, escaped, but the house was gutted.

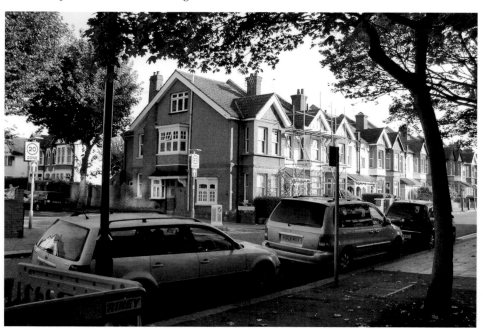

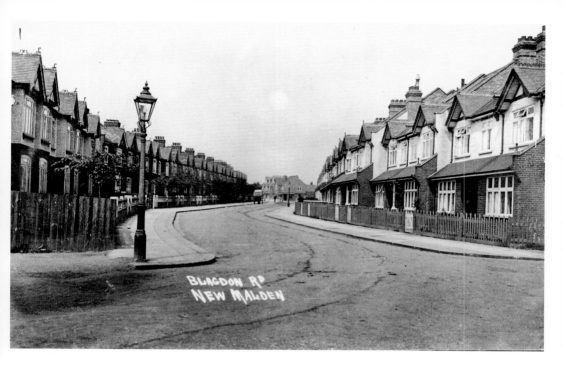

Blagdon Road

This is the junction of Blagdon Road, with Alverstone Road off to the left, pictured in the 1920s. Blagdon Road was laid out in 1896 with Alverstone added in 1909. The distant trees mark the Beverley Brook, beyond which was Blagdon Farm.

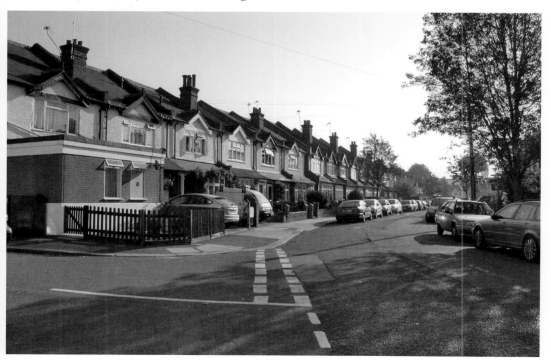

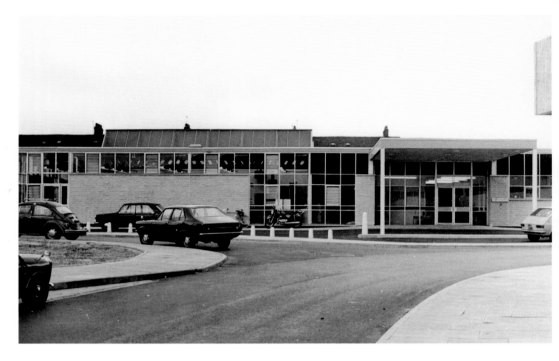

Crescent Resource Centre

This rather dull building was opened as 'The Handicapped Centre' in 1976 in Cocks Crescent. Later renamed the Crescent Resource Centre it, along with the Causeway Centre next door, provided many facilities for disabled people in the borough. Services ceased despite many protests in 2011 and the buildings are now boarded up.

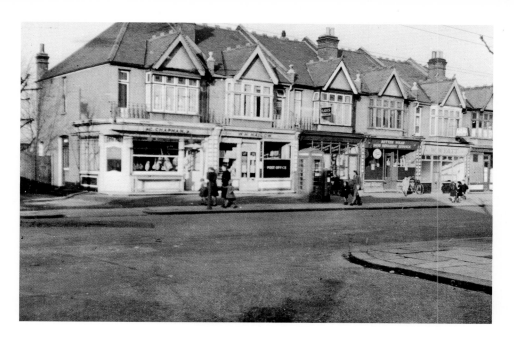

Burlington Road

This row of seven shops was built as The Parade at the turn of the last century, and Mr Chapman, the butcher, installed himself in what is now 89 Burlington Road in 1910. The 1950s photograph was taken just before Mr Chapman handed over to Mr Singleton. Today, Plumbing Supplies replaces Better Wear Shoes, and Spicy Island replaces the old fish and chip shop, but the butcher's premises has gone completely, replaced by a lock-up garage.

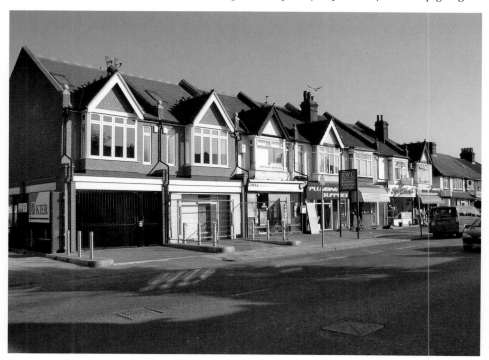

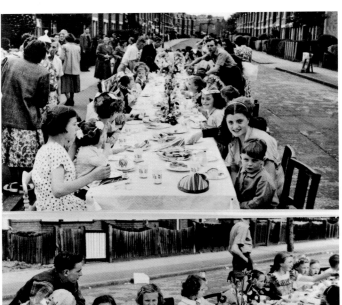

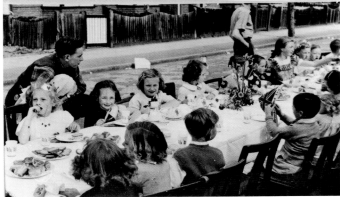

Coronation Day I
Just opposite the Burlington Road shops is Queens Road, an appropriate name, where the inhabitants gathered for a grand coronation party in June 1953. If they celebrate the Diamond Jubilee in the same style in 2012, they will have to find somewhere else to put all those cars.

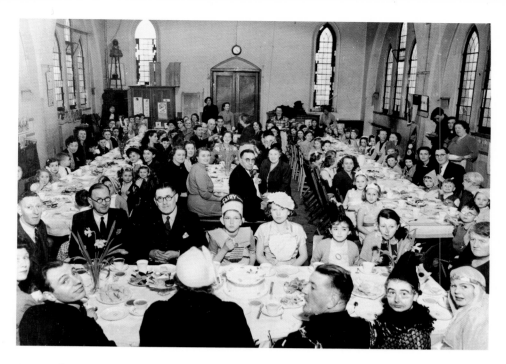

Coronation Day II

Unfortunately, shortly after the Queens Road street party photograph was taken, the heavens opened, and the party had to disperse and reassemble in St James' church hall. This hall had been the original St James' church in Burlington Road from 1903 until 1933 when it became the church hall. A new hall was built next to the new church in 1966 and this old hall was sold off and demolished. Now it is another office block.

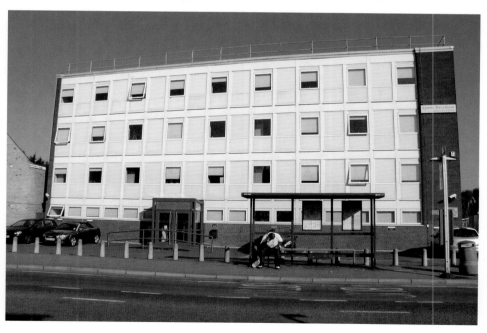

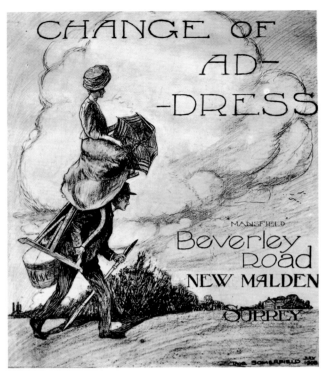

Home Sweet Home

This beautiful hand-drawn 'Change of Address' postcard was sent by Thomas Somerfield to his friend Monty in 1908. It seems to show a country house surrounded by fields, but in reality 'Mansfield' in Beverley Road was one of the first of a row of Edwardian terrace houses. A couple of years later it became No. 6 and, since the 1920s, it has been No. 14. Thomas evidently didn't settle and left in 1909, just a year after moving in.

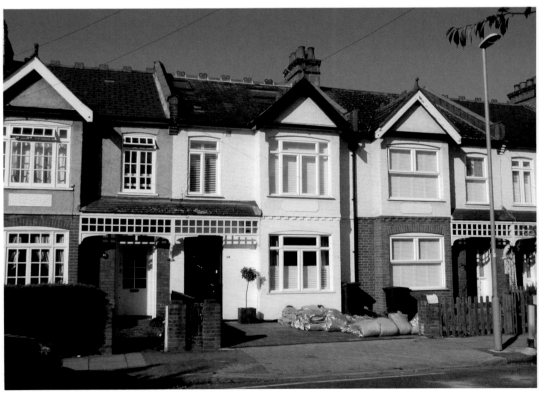

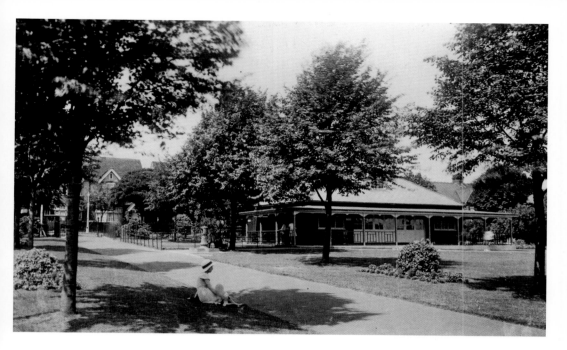

Beverley Park

Beverley Park lies to the east of New Malden and was created in the Edwardian period out of fields belonging to Blagdon Farm. These photographs were both taken in September – one in 2011 and one in 1938 – from the centre of the park looking west to Park View Road. The pavilion dates from the 1920s.

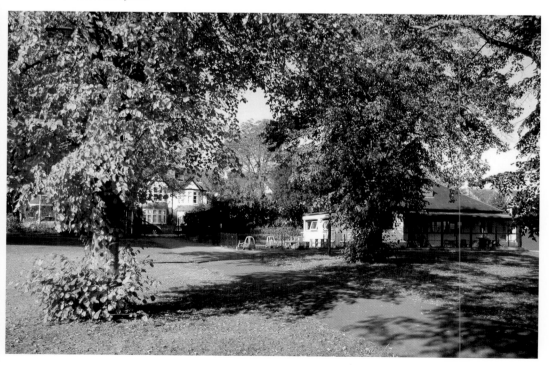

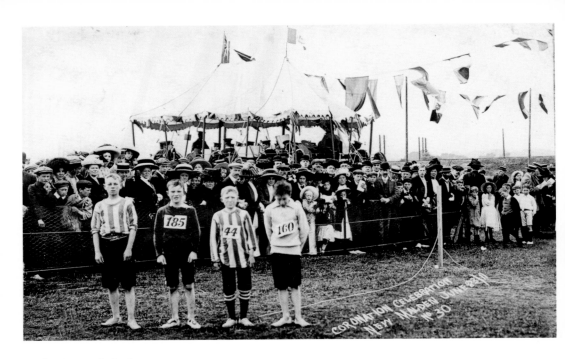

Under Starter's Orders

The first big event to be held in Beverley Park was the celebration of the coronation of George V in 1911. After the clock unveiling at the municipal offices, the band of the 3rd East Surrey Regiment led the way to Beverley Park where they played the national anthem in the temporary bandstand before a series of children's races were organised. This probably took place in the vicinity of today's tennis courts.

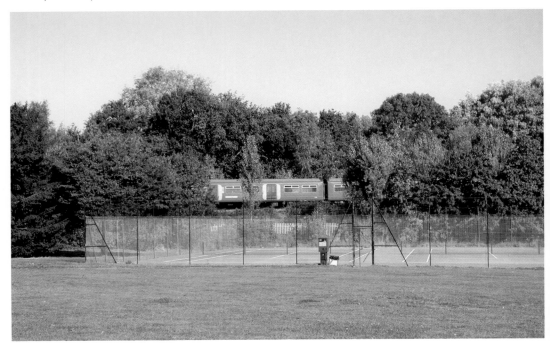

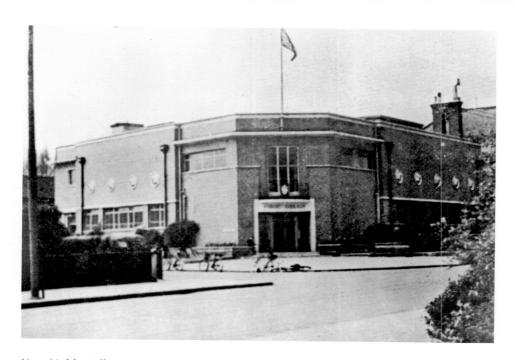

New Malden Library

New Malden Library is pictured here from a 1950s Borough guidebook. There had been a library committee since 1929 but the Depression put off any attempt at building until the late 1930s. Despite the outbreak of war, the building work continued and the library was opened in 1940. Later in the war, Noel Streatfield of *Ballet Shoes* fame gave a talk there.

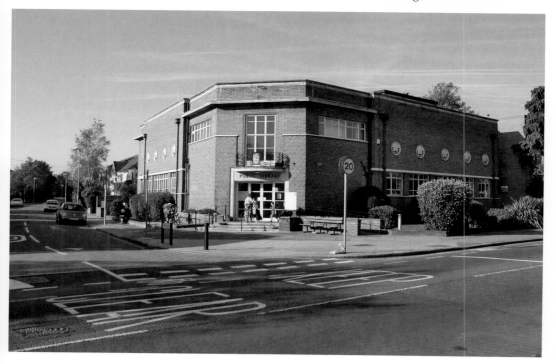

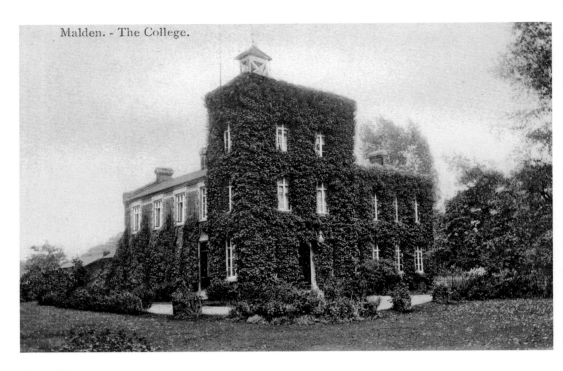

The College
The College was founded in New Malden *c.* 1880 as a day and boarding school for boys. During the First World War it became a clothing factory but was a school again in the 1920s called St George's School. This appears to have been short-lived and the site is now covered by Welbeck Close.

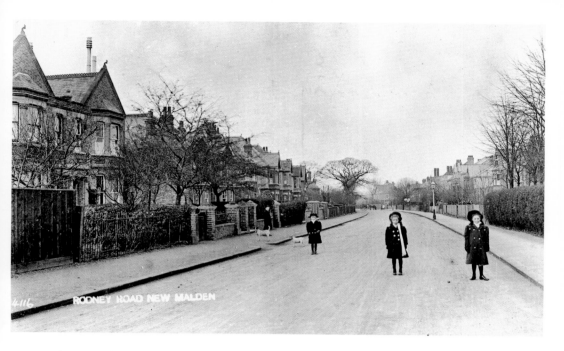

Rodney Road

The postcard featuring the three girls playing in the street dates from around 1900, shortly after the houses were built, although the road itself seems to have been laid out in the 1860s as part of the Norbiton Park Estate. Rodney was a naval hero of the late eighteenth century, and there is a Nelson Road nearby as well. Today cars replace the children.

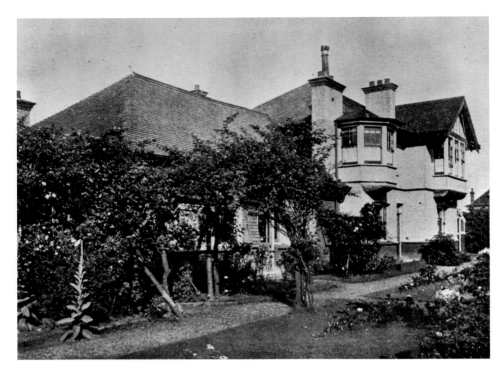

Holy Cross School

There has been a school on this site in Sandal Road since 1906. As the postcard of 1938 states, it was originally Sandal Dene School for Girls run by Miss Arnold and Miss Merryweather. Miss Merryweather lasted until 1940 but then seems to have retired. The buildings were taken over by the neighbouring Roman Catholic school for girls, Holy Cross, which now covers a large area. None of the original Sandal Dene buildings survive.

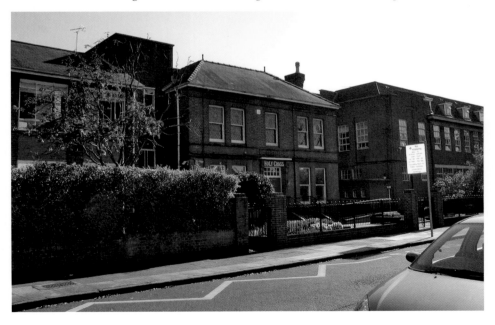

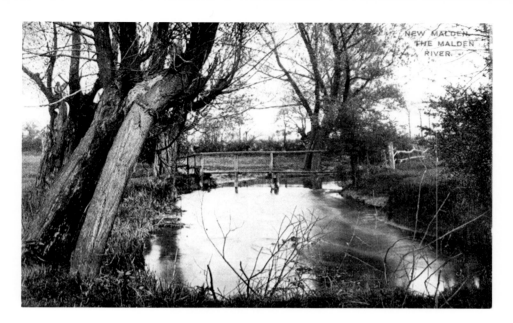

The Malden River

The original postcard view is taken looking south towards a rickety footbridge in *c.* 1910. Although called the Malden River here, the correct name is the Hogsmill. Since 1910 the Hogsmill has been straightened, and a new cycle and footbridge have been built at the west end of Green Lane. Today's view looks eastwards.

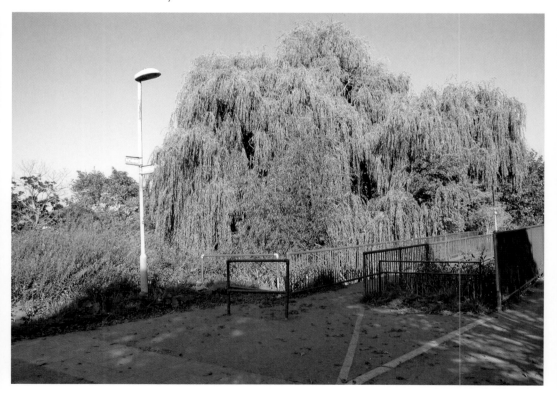

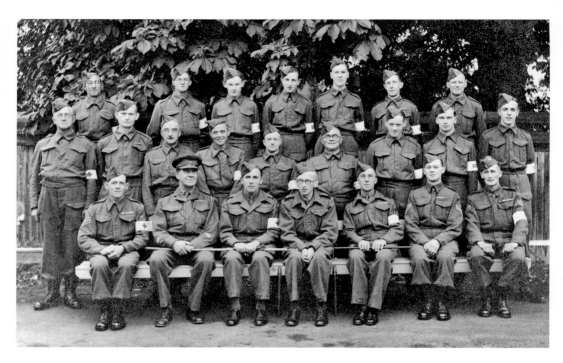

Dad's Army
This is the medical corps of New Malden Home Guard (51st East Surreys) photographed in 1940–41 at the Prudential Sports Ground by Windsor Avenue. Today the sports grounds are owned by King's College, London, but many different clubs and schools use the facilities, including the very picturesque 1930s clubhouse.

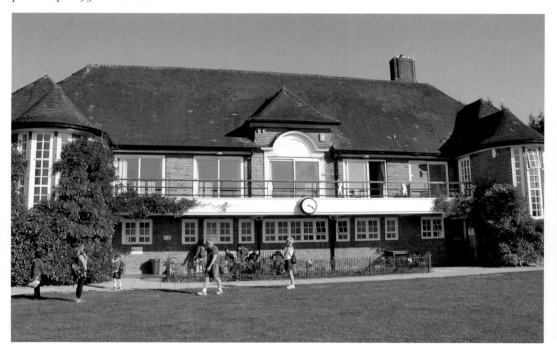

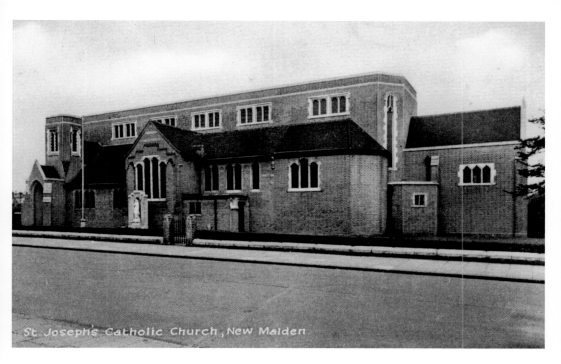

St Joseph's Catholic Church, New Malden.

St Joseph's Roman Catholic Church

New Malden's Roman Catholics spent many years travelling to St Agatha's in north Kingston for Mass, until an anonymous benefactress donated the site at the junction of Kingston and Montem Roads in 1905. This splendid church was finally opened in 1922 and consecrated in 1951 when the building debt was paid off.

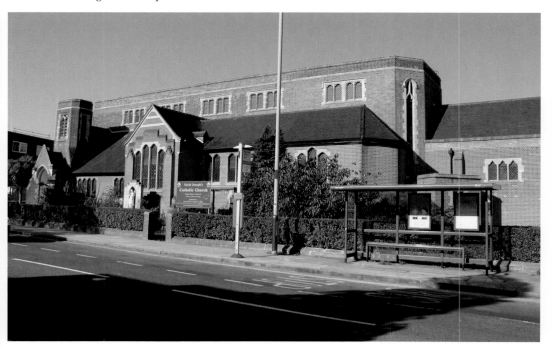

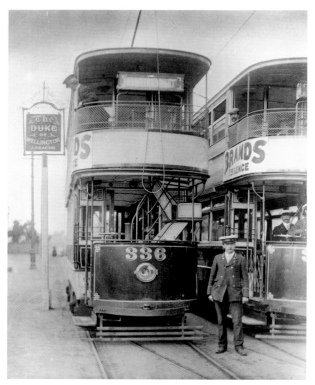

Trams in Kingston Road

This photograph of trams was presented to Malden Borough by Mr Johnson MBE, the Town Clerk. He had also been Clerk of the Council from 1907 to 1936 when New Malden was an Urban District Council, so he had seen the trams arrive in 1906 and depart in 1931. The Duke of Wellington (now just The Wellington) has been here since before 1828.

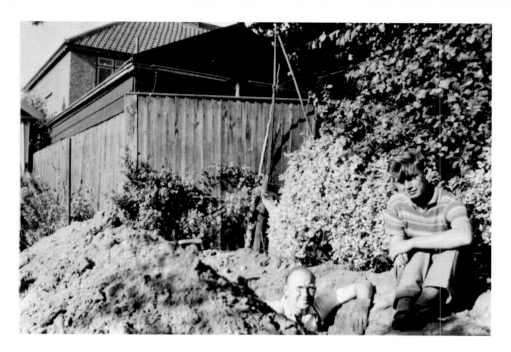

Is it Deep Enough Yet Dad?

Mr Martin, who lived at 52 Franks Avenue, was very disparaging about Anderson air-raid shelters and, on the day war broke out, is seen here digging a First World War style trench in his back garden. A bomb did fall nearby in 1940 destroying his neighbour's Anderson shelter but leaving Mr Martin's trench unaffected. Fortunately, no-one was hurt.

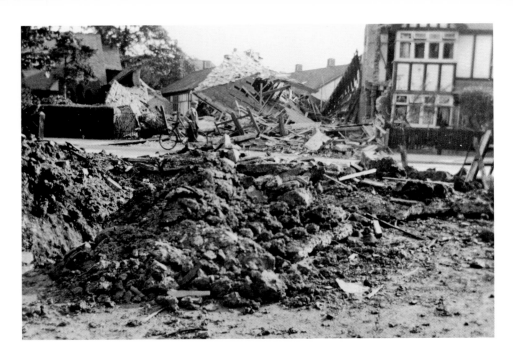

New Malden at War

Elsewhere in New Malden there were casualties, with over eighty people killed, many in a heavy raid in August 1940, which targeted the railway junction by the station. This damage is near the junction of Kingston and Westbury Roads, and the modern picture shows one of the many 1950s houses in New Malden that filled in the gaps after the war.

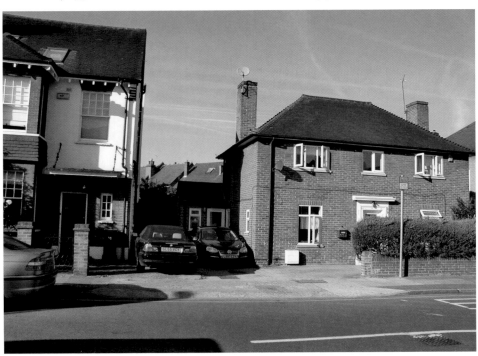

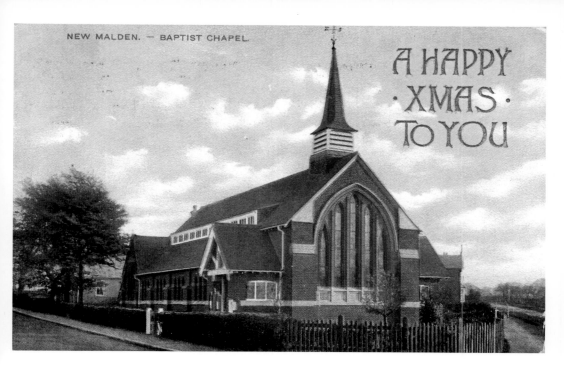

NEW MALDEN. — BAPTIST CHAPEL.

A HAPPY ·XMAS· TO YOU

The Baptist Chapel
Another victim of the bombing was Kingston Road's Baptist chapel. This had been built in 1891, replacing an earlier structure, and is pictured here in 1911 on a Christmas postcard. It was gutted by bombing on 16 August 1940 and the new chapel opened on the site in 1953.

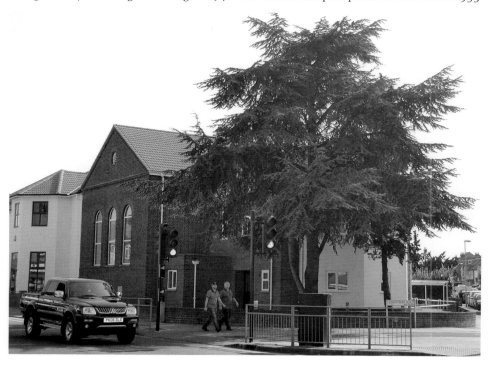

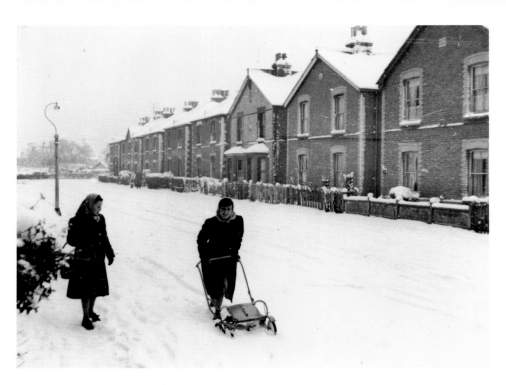

From One Extreme to Another

These two pictures feature Northcote Road, just off Elm Road. The snowy picture was taken in April 1963, the harshest winter in the author's lifetime (he was born during it!) The sunny picture was taken in 29°c on 1 October 2011, the hottest October day for 100 years.

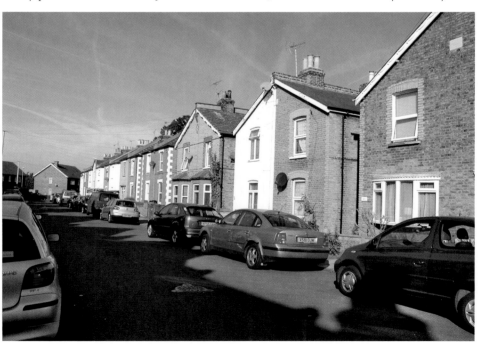

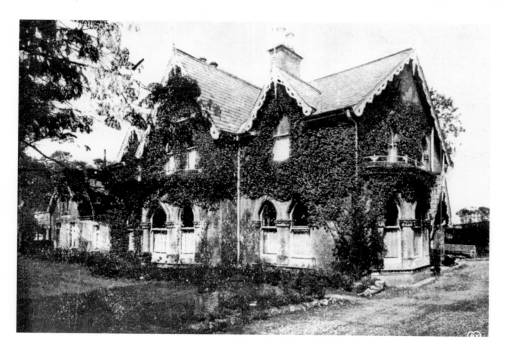

A Short-Lived Hotel

This lovely Victorian house was called Woodfield and stood at the junction with Malden Road and the later bypass. In 1937 it opened as a hotel but seems to have closed during the war. Afterwards it became a council rest home for the elderly, but was demolished in 1960 and replaced by these Woodfield House flats.

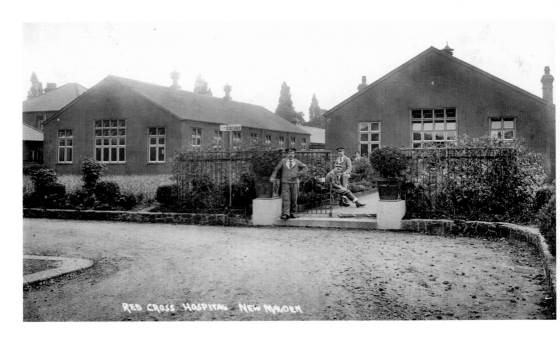

The Red Cross Hospital

A branch of Springfield Hospital was set up on the Kingston Road in the old Norbiton Common Farm buildings just before the First World War. In 1915 it became the Red Cross Hospital for wounded soldiers and many new buildings were added. This postcard was sent from there in December 1916. After the war it reverted to Springfield (New Malden Branch) Hospital, then the Morris Markowe Unit, before being pulled down in 1991. The site is now covered by the houses of Georgia, Springfield and other nearby roads.

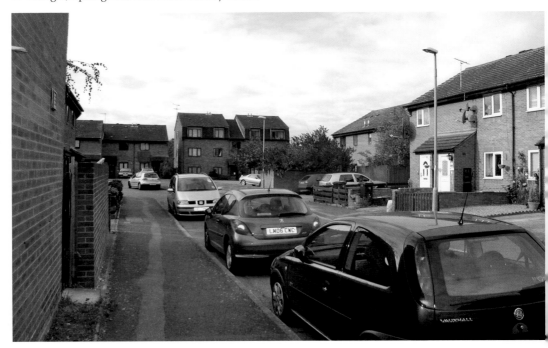

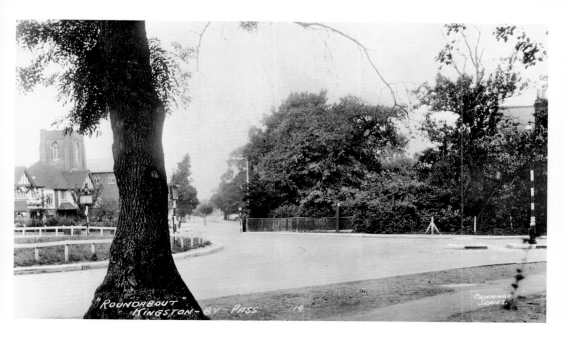

Bigger and Wider

In the 1930s, Kingston bypass crossed the Malden Road just south of St James' church at this roundabout. Just in front of the church can be seen the black and white buildings of 193 to 199 Malden Road (193 being the vicarage), which were pulled down in the 1960s when the roundabout was greatly enlarged and the bypass went through on a 'Flyunder'.

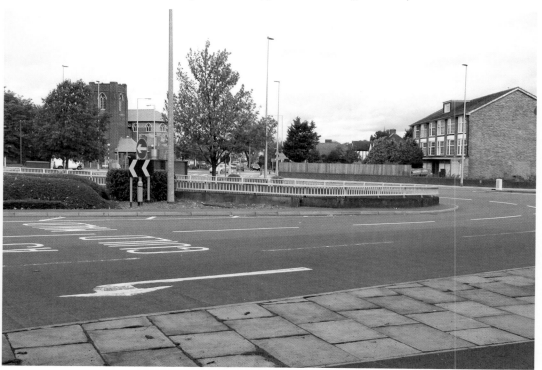

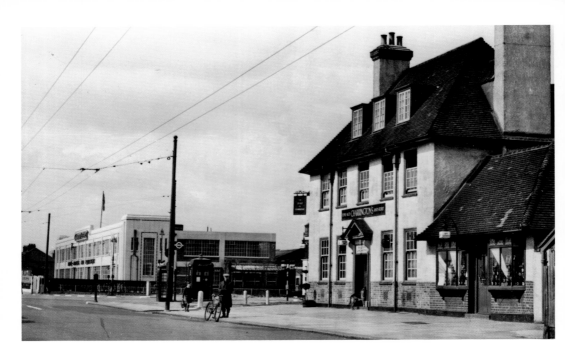

The Duke of Cambridge

This is Shannon Corner, technically outside the Borough of New Malden and in the Borough of Merton, but most people agree it still counts as New Malden. The Duke of Cambridge pub shut around five years ago and is now a Krispy Kreme donut outlet. The new large B&Q replaces the 1930s Shannon Office Stationary Factory, and the A3 now cuts through on a flyover.

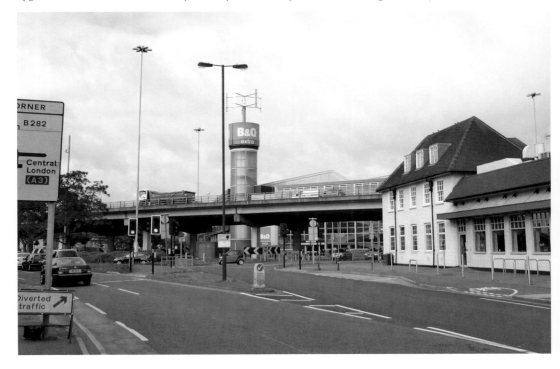

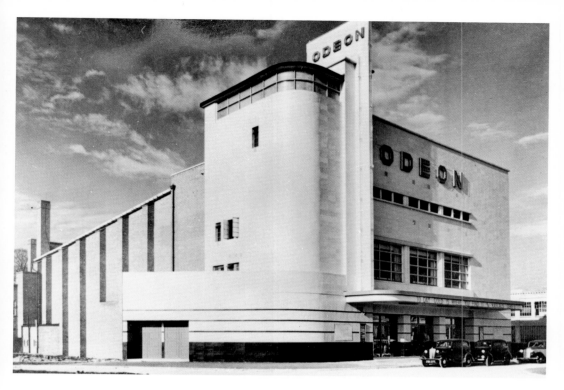

A Lost Architectural Gem

On the opposite side of the Shannon Corner interchange, New Malden's Odeon was opened in 1938. It seated 1,600 people and the first film shown was *Gold is Where You Find It* starring George Brent and Olivia de Havilland.

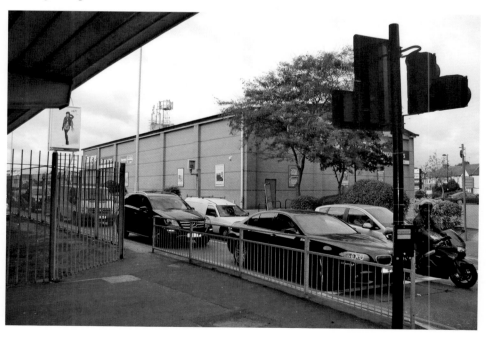

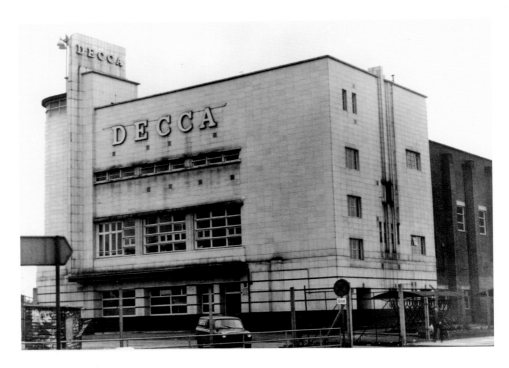

A Slow Decline

The great 1930s flourishing of cinema – the Odeons in particular – proved short-lived. In the 1950s people stayed at home to watch television, and the Shannon Corner Odeon closed on 2 January 1960, shortly before the flyover was erected. Decca Gramophones took it over as a store and it was renamed the Beverley Building. It was demolished in 1985.

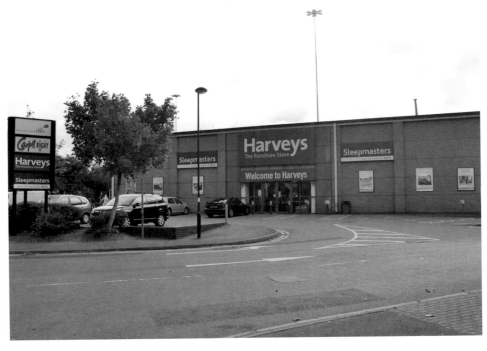

By-Pass Parade, New Malden.

Who Put That Bridge There?

The black-and-white postcard shows the newly opened shops of The Parade, Malden Way, in 1932. A sweetshop can be seen, and Albert Carter the butcher who left by 1939. This section of the bypass is just by Queen's Road and the concrete footbridge was erected in the late 1950s. This seems to have killed off the shops, and the buildings (now 43–49 Malden Way) are currently small offices and flats.

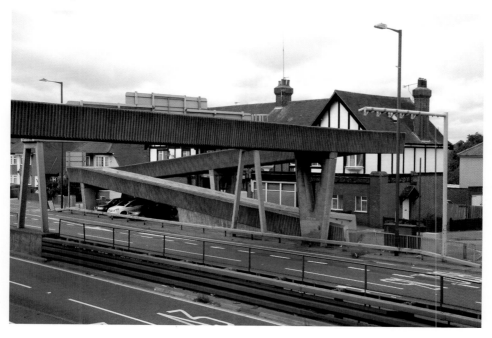

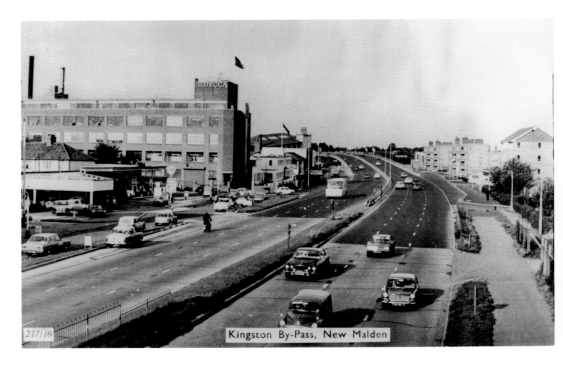

Kingston By-Pass, New Malden

217/16

View from a Bridge

Although ugly in appearance, the footbridge does give a good view of the A3, shown here when the bridge and distant flyover were both new. The flyover is that at Shannon Corner. The Decca building has now gone and one can see through to the new B&Q. Surprisingly, the traffic looks about the same in both shots.

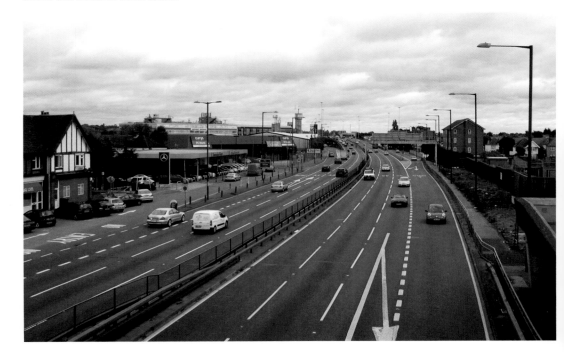

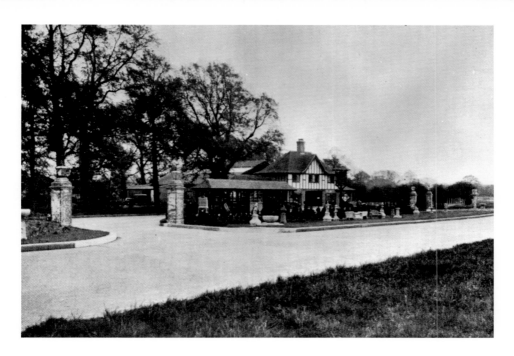

The Gold Medallist Petrol Station

Kingston bypass was opened in 1927, the first bypass in the country, which developed into the A3. This petrol station was built in the 'Tudorbethan' style to serve motorists in 1938 and I think it was probably where the Mercedes-Benz showroom is today, but I have been unable to trace it for certain.

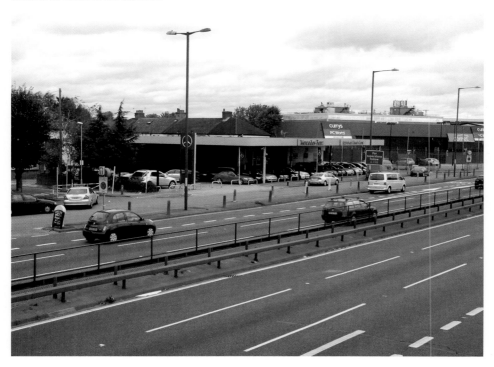

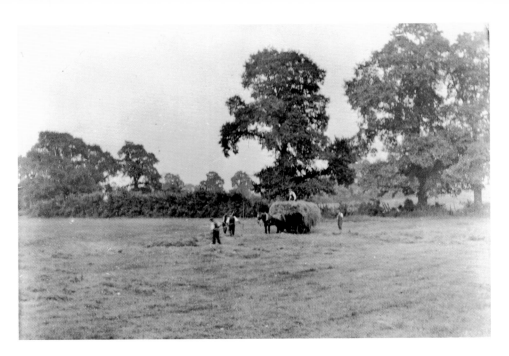

The Rural Past

Before the coming of the railway, the area now covered by New Malden consisted principally of farmland and Norbiton Common. This scene of haymaking south of Coombe Lane dates to the 1920s, just before the last of the farms disappeared under new houses. Pictured below are a couple of houses on the Coombe Berg Estate of the 1930s, which featured 'Modern Style' houses as well as the more typical 'Tudorbethan'.

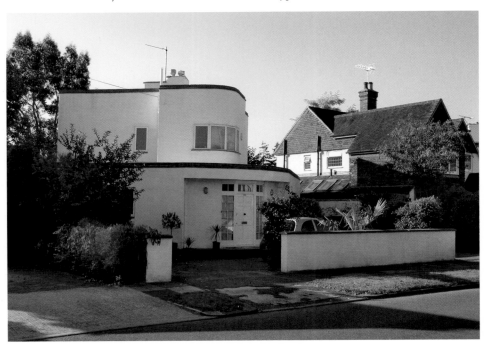

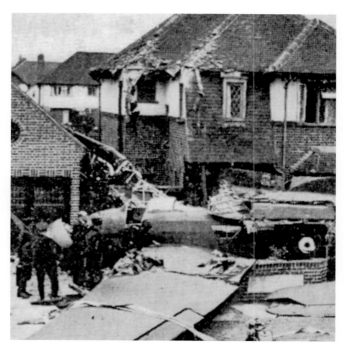

Plane Crash!

The peace and quiet of the Coombe Berg Estate was shattered on 5 July 1937 when a Vickers Wellesley bomber crashed into the front garden of 77 Woodlands Avenue. The test pilot, Mr Quill, had flown from Brooklands when he suddenly lost control of the aeroplane. He parachuted to safety, landing in the garden of a friend of his, Captain Peaty, in Coombe Lane. No one in Woodlands Avenue was hurt.

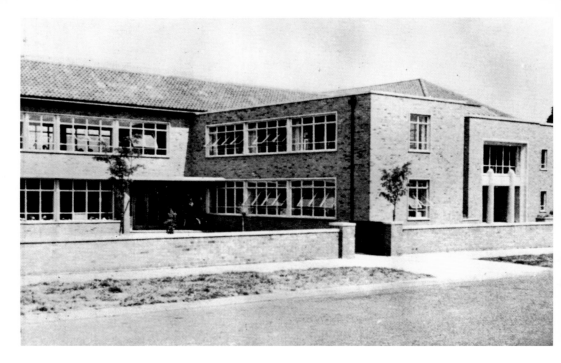

Coombe Girls' School

Coombe Girls' School has been a very popular local school since it opened in 1955 as Coombe County Secondary Girls' School in Clarence Avenue. It has been a specialist modern foreign languages school since 1999 and now has a shared sixth form with Coombe Boys (previously Beverley Boys). Its most famous former pupil is the children's author Jacqueline Wilson.

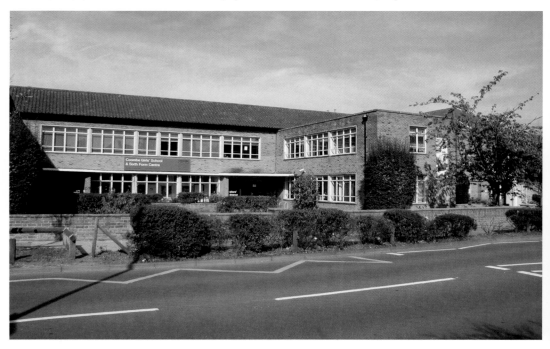

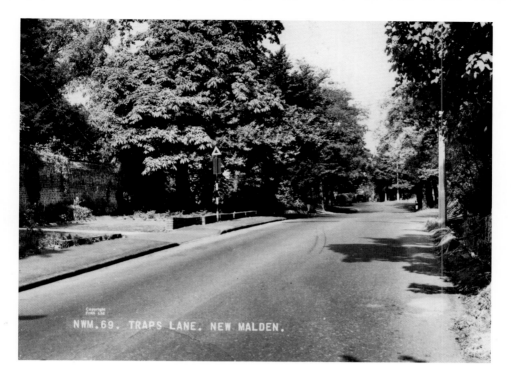

NWM.69. TRAPS LANE. NEW MALDEN.

Traps Lane

Traps Lane runs from Coombe Lane West south until it becomes Coombe Road and so on towards New Malden. It is named after an eighteenth-century owner of farmland, seen to the right of the photographs, called Madam Trapp. There has been little change between these two pictures of 1962 and 2011. The road off to the left is The Moat – not left over from medieval times, but rather a Georgian garden feature.

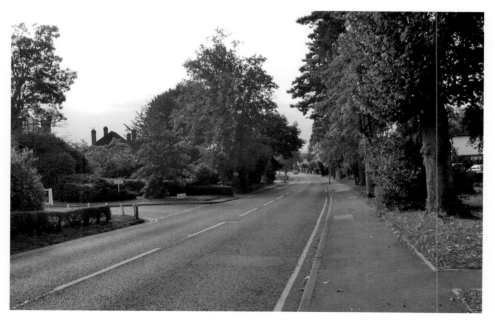

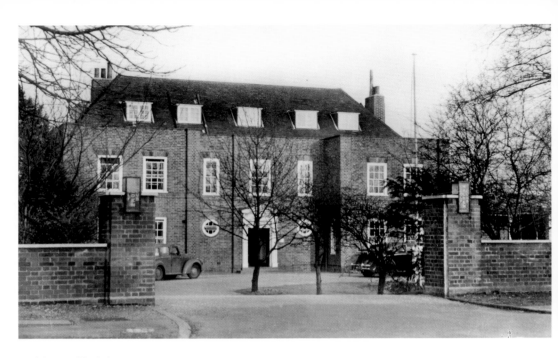

Malden Golf Club

Malden Golf Club started out as Raynes Park Golf Club in 1893, which was based around Grand Drive. The land there was sold for housing and the club moved to New Malden in 1926 when this clubhouse was built in Traps Lane. The round windows either side of the door are now square, but not much else has changed despite a serious fire in 1982.

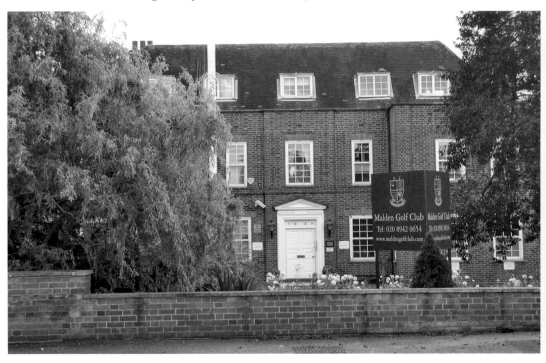

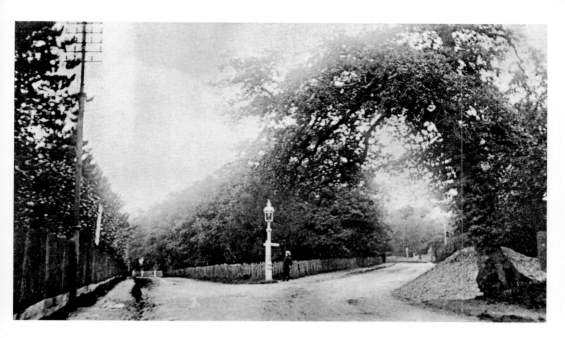

Barings Hill

Over 100 years ago, this part of Coombe Lane West was known as Barings Hill. In the 1790s the owners of Coombe Farm (now Coombe Hill Junior School) pushed Coombe Lane northwards to give themselves more space. The slip road off to the left leading to Traps Lane was the original Coombe Lane. The area was known as Barings Hill because Edward Baring of Barings Bank lived on the north side from 1863 to 1885.

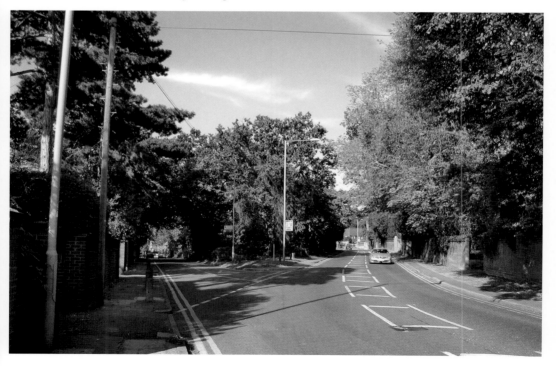

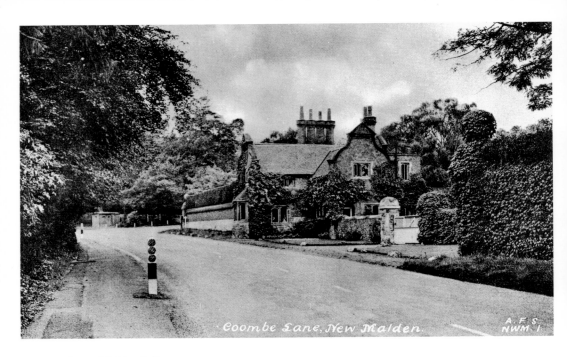

Coombe Lane, New Malden.

A.F.S
NWM 1

A Second World War Relic

A little further along Coombe Lane is the original lodge house for Coombe Warren, a great mansion on the hill. The lodge has been a separate house since the First World War. At the back left of the 1950s photograph you can make out a pill box covering the junction with Traps Lane. Hundreds of these were built in 1940–42 in case Hitler invaded, but most, including this one, have sadly disappeared.

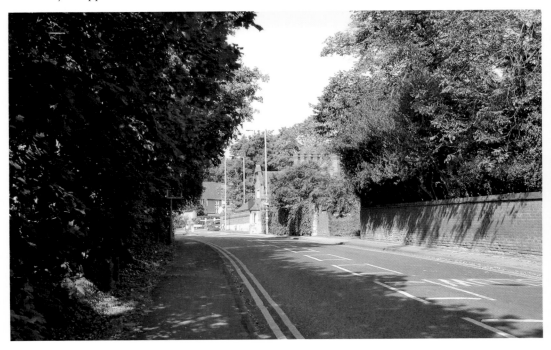

Coombe Conduit

On Coombe Hill there are three of these conduit houses, with Coombe Conduit on Coombe Lane being the largest. They were built in the early sixteenth century to tap spring water and pipe it through Kingston, under the Thames to Hampton Court Palace. Originally thought to have been built by Cardinal Wolsey, it is now believed they were built by Henry VIII when he was given the palace.

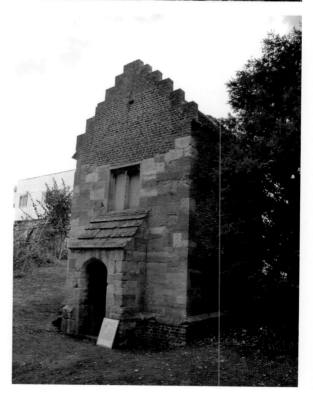

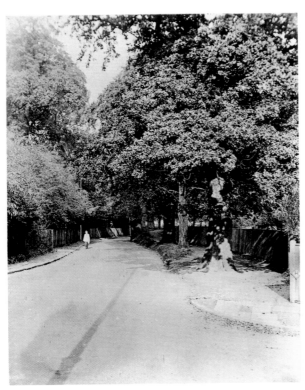

Near Page's Farm
The photograph from the 1920s states that this is Coombe Lane, near Page's Farm. This was once Coombelane Farm, the buildings of which now lie under Wolsey Close, but this picture is further east at the junction with Dickerage Road on the left. George Page was secretary of the Kingston Branch of the National Farmers Union from 1916 to shortly after 1930 when he sold up.

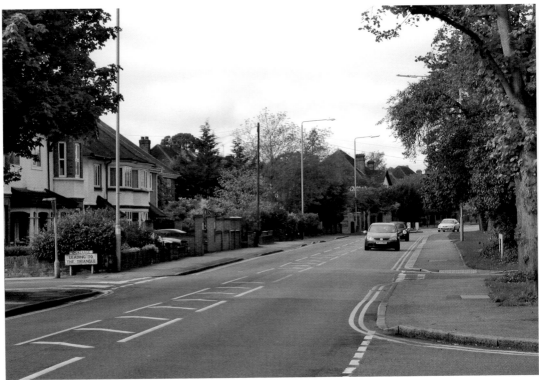

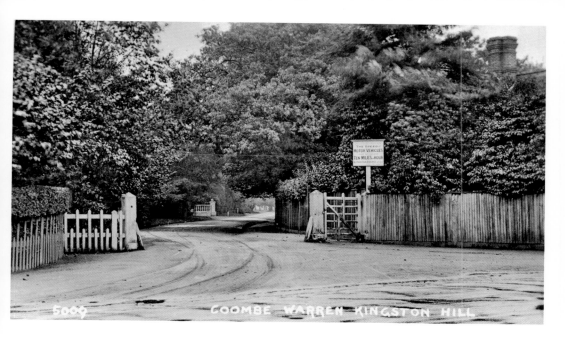

Coombe Warren

In 1837 the entire Coombe Estate was bought by the Duke of Cambridge who tried to close off Warren Road to the general public. He was taken to court by the locals in 1853, who proved it was an ancient right of way. Carriages, however, were not allowed and private cars are still forbidden to use Warren and George Roads. There is a barrier at the Coombe Lane end. This is the Kingston Hill end where the 1910 postcard shows permitted cars are restricted to 10mph.

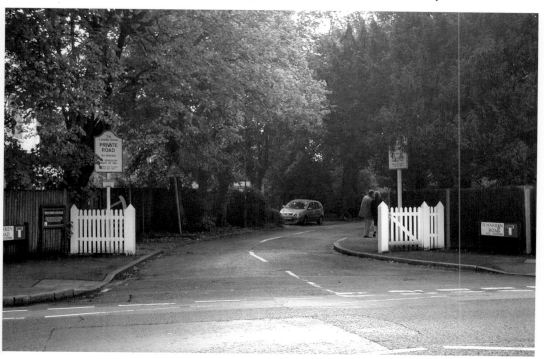

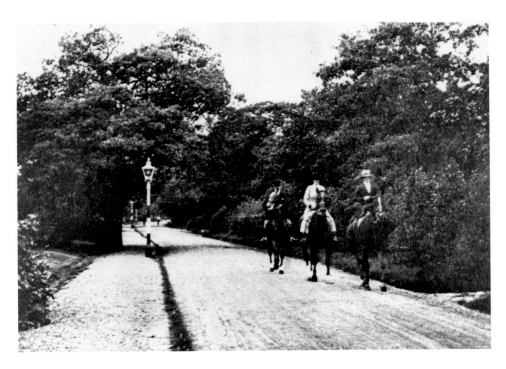

The Coombe Estate

The horsemen trotting peacefully down Warren Road were featured in a 1938 guide to Malden and Coombe. The picture may be much earlier but then nothing much has changed, and the benefits of keeping out private cars can be seen. This view is looking westwards with Coombe Hill golf course on the left.

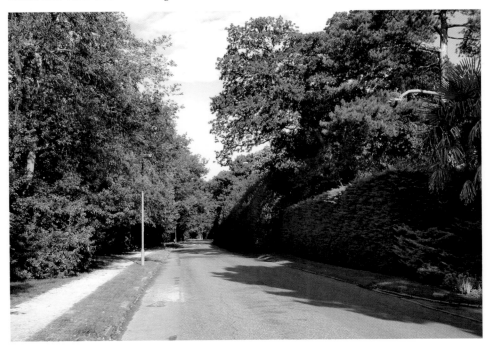

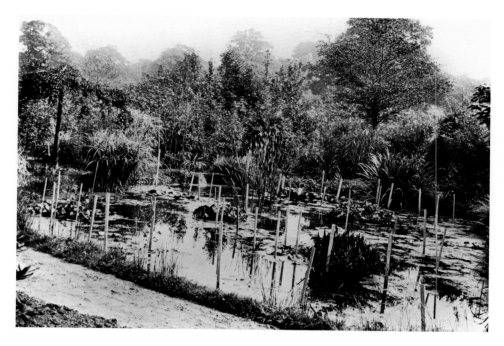

Veitch's Water Gardens

In 1863, James Veitch acquired thirty-five acres of Coombe Wood and set out the Coombe Wood Nursery, which fed Britain's booming interest in gardening. He introduced many new plants to Britain and laid out water gardens, a part of which is shown here in 1903. Today Warren House and the Water Gardens apartments cover the site, but parts of the Victorian water gardens survive and can be visited at Warren House on Heritage Open Day.

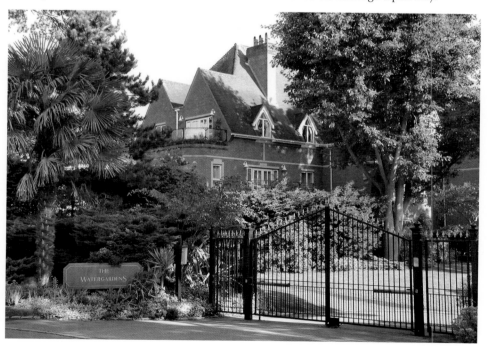

Telegraph Cottage

Telegraph Cottage was named after a nearby semaphore station, which transmitted messages between London and Portsmouth in the nineteenth century. During the Second World War, General Eisenhower stayed here and much of the planning for D-Day was carried out here. One of the maps he used is in Kingston Museum. In 1980 developers were refused permission to demolish it but it 'mysteriously' burned down shortly afterwards. A new Telegraph Cottage stands there today.

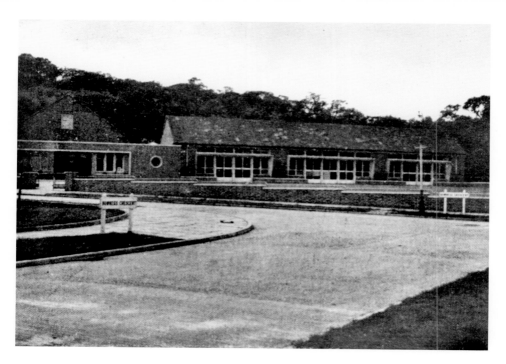

Robin Hood School

North of Coombe is an area of the Borough called Kingston Vale where Kingston Hill runs down to Putney Vale, but the name Robin Hood has also been associated with the area since the sixteenth century. Robin Hood Games were played in Kingston and there was a Robin Hood Walk in what is now Richmond Park. Robin Hood School opened in 1949 in Bowness Crescent.

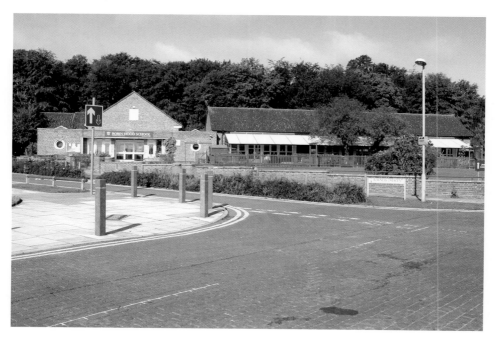

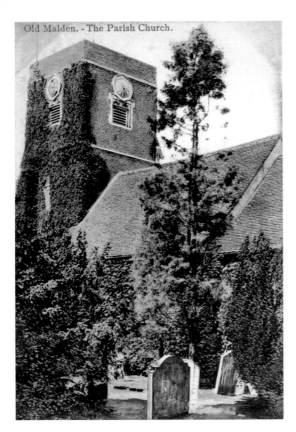

Old Malden. - The Parish Church.

A Domesday Church

A church is mentioned at Malden, which means 'Cross on a Hill' in the Domesday Book of 1086, and this became known as St John the Baptist's church. The original church would have been wooden but it was rebuilt in stone in medieval times. The surviving parts of this stonework can be seen in the modern photograph here. By Elizabethan times the church was virtually a ruin, and all the brickwork and the tower are from a major restoration of 1610–11.

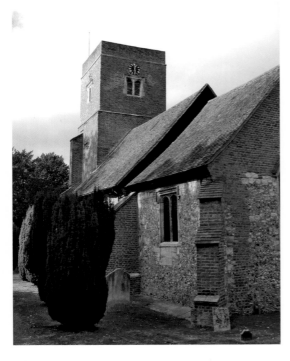

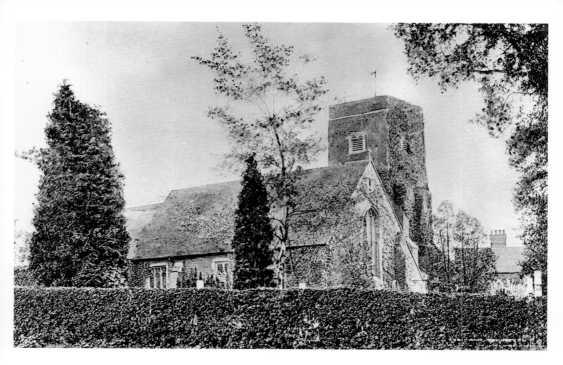

St John the Baptist

The population of Old Malden grew in the nineteenth century and the new nave, doubling the size of the church, was built in 1875. The modern photograph shows a further extension from this nave, which was completed in 2004 with a new vestry, hall, kitchen and other facilities.

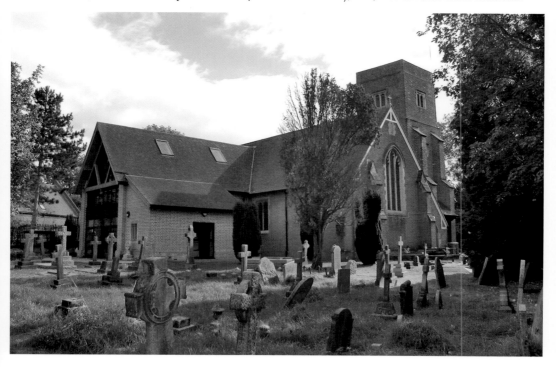

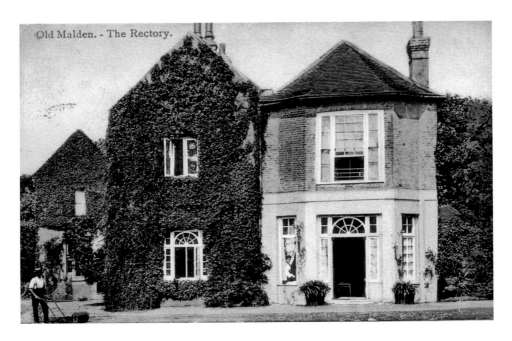

Old Malden. - The Rectory.

The Old Vicarage

Thought to date from the reign of Queen Anne, excavations in 1997 showed that a vicarage had stood on the opposite side of Church Road from the church since the early seventeenth century. This was greatly enlarged in Victorian times but was demolished in 1936 and replaced with a smaller vicarage to the south. This was demolished in its turn in 1997 and another vicarage and six houses (Vicarage Close) were built on the site. Some large trees still remain from the original vicarage garden.

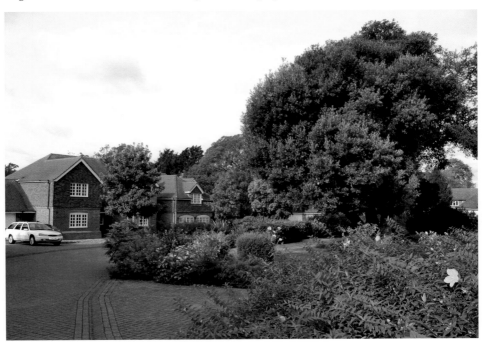

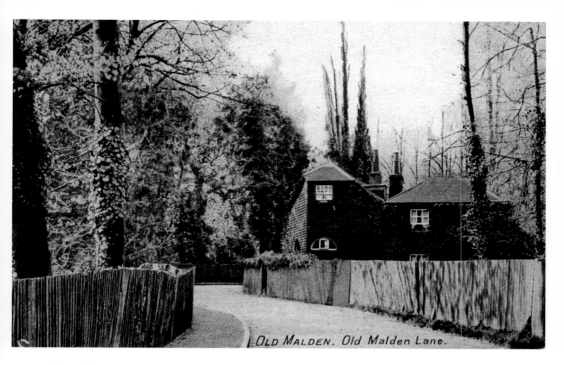

Old Malden Lane

This postcard was sent in 1909, although the view may be earlier. I believe this shows the path beside St John the Baptist's church, which is on the left, the large trees having been cut down. The farm buildings were converted into housing in 1997.

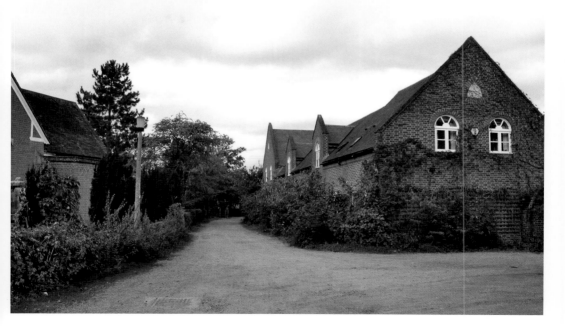

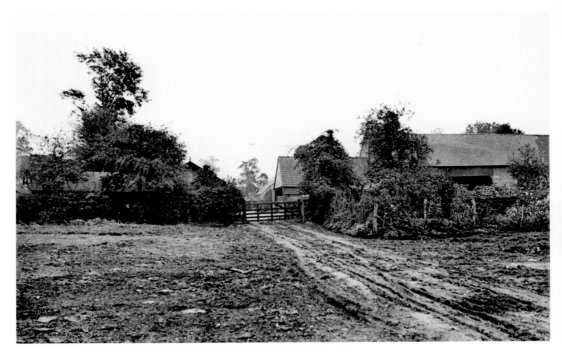

Manor Farm

Manor Farm lay just to the north-east of St John's church. In the old photograph of 1934 the church is out of shot to the right. The buildings were converted into housing in 1997 and the modern photograph has the church some way to the left. Manor Farm's 'claim to fame' is that it was the first local farm to have its animals tested for TB in 1900.

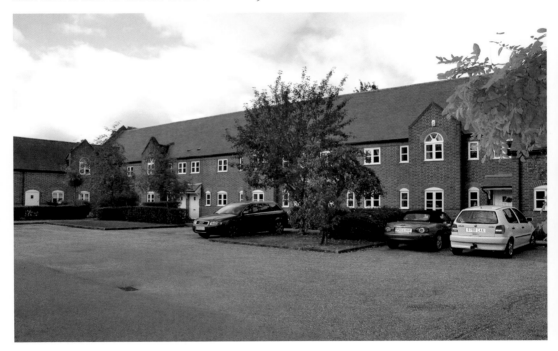

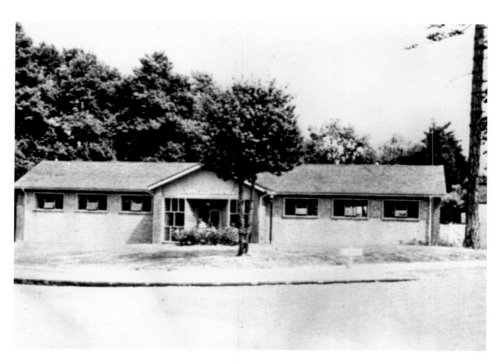

Old Malden Library

Old Malden finally got its own library in 1954. As can be seen, it hasn't changed at all since then, although it has been threatened with closure on a couple of occasions. It had a major refurbishment in 1992 and is now seen as an important community hub for the area.

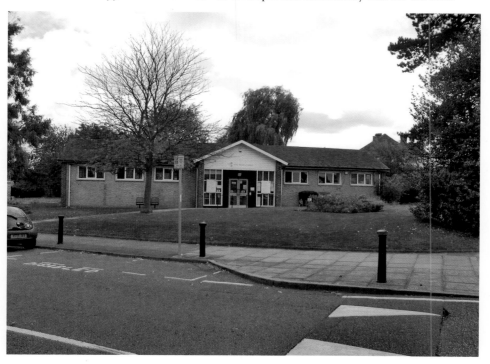

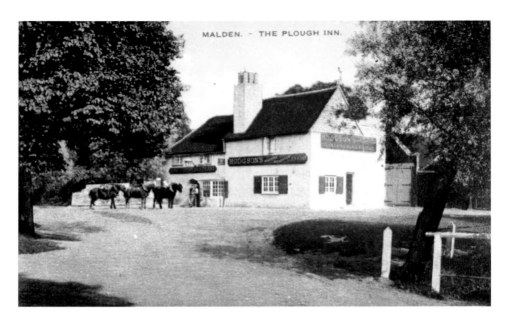

The Plough Inn

The Plough Inn on Church Road is an old coaching inn dating back to at least the fifteenth century and allegedly a hangout for highwaymen like Dick Turpin and Jerry Abershaw. To the right is an ancient pond through which carts used to ford before it was properly bridged. Today it has a nice selection of ducks, and when I was there, a very large heron on its nest.

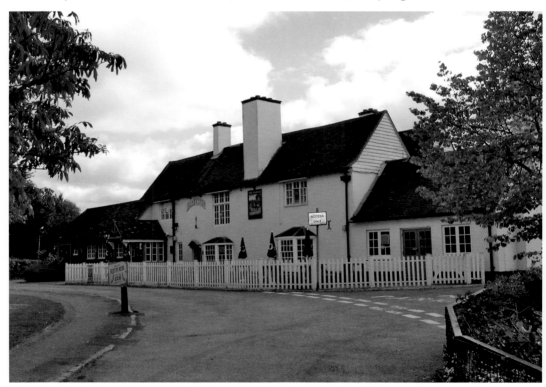

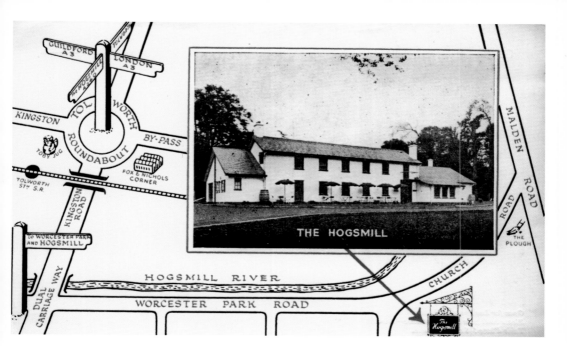

The Hogsmill

The Hogsmill

The stylised map on this 1930s card of the Hogsmill is not very useful when approaching from Old Malden, as the pub is a lot further along Church Road (Old Malden Lane) than suggested. It is, in fact, across the border in the Borough of Epsom and Ewell. The back of the card offers 'Table d'hôte' at 5/6 or 'à la carte', and the phone number was 'Derwent 9309'. Now it is a Toby's Pub and Carvery.

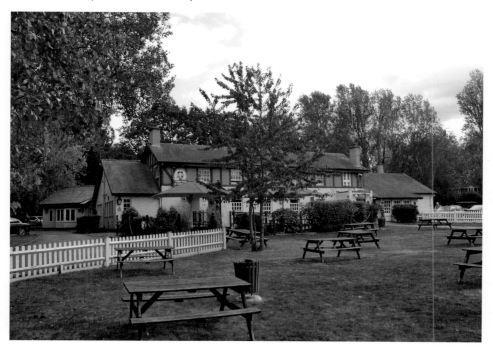

Beverly Woods, New Malden

We finish off with a mystery photograph. This photograph would appear to date from 1910 to 1920 and is captioned 'Beverley Woods, New Malden'. I have been unable to trace this location with any certainty. There are, or were, woods at various points along the line of the Beverley Brook, from Coombe Wood in the north, to the areas around New Malden Golf Club or perhaps further south. I cannot find 'Beverley Woods' on a map. If you know where it is please let me know!

Acknowledgements

The old photographs on pages 6–14, 16, 18, 20–1, 23, 38, 42, 50–51, 54, 59, 68, 71–2, 77–8, 90–91 and 95–6 were kindly lent by my sister-in-law, Amanda Tree. Those on pages 63 and 66 are from the collection of my wife Shaan. All other photographs are used with the kind permission of Kingston Museum & Heritage Service.

I would like to thank the staff at Kingston's Local History room, namely Jill Lamb and Emma Rummins, for their help with this work. I would also like to thank Robin Gill and Amanda Tree for advice on some aspects of some of the pictures, and especially my wife Shaan for many useful snippets of knowledge, and for her extensive notes on churches in the area. Use has also been made of the following books:

Margaret Bellars *Kingston Then and Now* Michael Lancet 1977

Stephen Day *Malden Old and New* Marine Day 1990

Stephen Day *Malden Old and New Revisited* Marine Day 1991

June Sampson *All Change* (Revised Edition) News Origin 1991 (and also her many articles in *The Surrey Comet*)